North Carolina's State Historic Sites

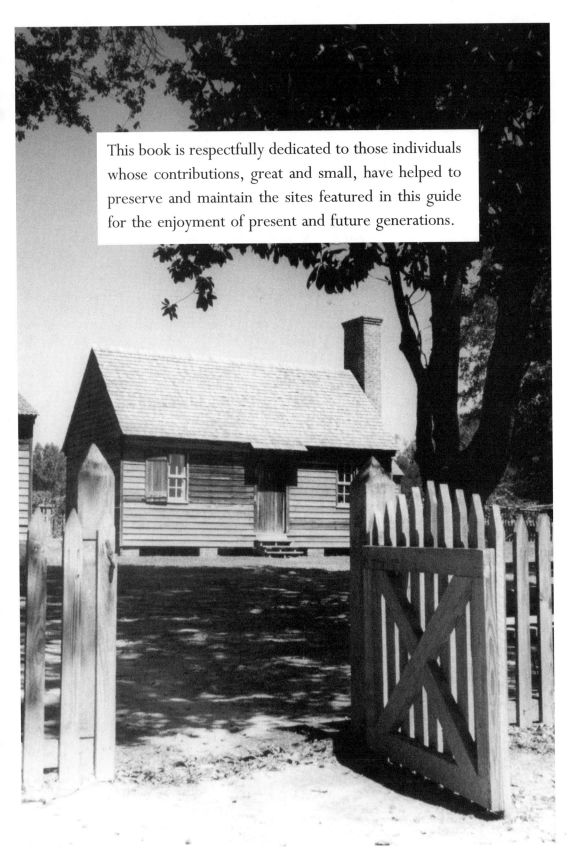

This book is respectfully dedicated to those individuals whose contributions, great and small, have helped to preserve and maintain the sites featured in this guide for the enjoyment of present and future generations.

An open gate welcomes visitors to the Aycock homestead.

North Carolina's
State Historic Sites

Text and Photography (unless noted) by
Gary L. McCullough

John F. Blair, Publisher Winston-Salem, North Carolina

Published by John F. Blair, Publisher

Copyright © 2001 by Gary L. McCullough

The paper in this book meets the guidelines
for performance and durability of the
Committee on Production Guidelines for
Book Longevity of the Council on Library Resources

Library of Congress Cataloging-in-Publication Data

McCullough, Gary L., 1950-

North Carolina's state historic sites / by Gary L. McCullough.

p. cm.

Includes bibliographical references and index.

ISBN 0-89587-241-2 (alk. paper)

1. Historic sites—North Carolina—Guidebooks. 2. North
Carolina—History, Local. 3. North Carolina—Guidebooks. I. Title.

F255.M38 2001

917.5604'44—dc21

2001035856

Contents

Foreword

*I*n 1955, seven historic properties were transferred from the state parks system to what was then the North Carolina Department of Archives and History. Thus began the system of state historic sites, which has continued to provide enjoyment and education to countless thousands of adults and children. Several years after the program's creation, its first administrator noted that the development and operation of the state historic sites were "designed for the general public, not just the professionals." In this guide to the 22 sites, Gary McCullough has crafted a book that (like the sites themselves) will appeal to both groups.

I commend Mr. McCullough for his initiative and considerable effort in creating this publication. As will be apparent to all who read it, this book has been a labor of love for the author. Long before any publisher stepped forward, Mr. McCullough personally visited all the sites and took beautiful photographs for the book he planned to write. With no promise that his project would ever be published, he spent many hours writing historical sketches for each site, along with other helpful information. The finished book clearly reflects his love of the Tar Heel State, its history, and its historic places. While some historians may disagree with certain aspects of Mr. McCullough's interpretation, he nonetheless has performed a most valuable service by assembling such a broad sweep of North Carolina history in one publication. Readers wanting more detailed information about the history of the sites or the state should consult the many books produced by scholars at various universities and historical agencies, such as the Division of Archives and History.

I am very grateful to Mr. McCullough for this guide. I hope readers will come to share his interest and love for these very special places—North Carolina's state historic sites.

James R. McPherson
Administrator
North Carolina Historic Sites

Preface

North Carolina is a state rich in history, and its 22 state historic sites help to tell its story. Traveling to these sites, which stretch from the mountains to the coast, will give visitors opportunities to learn about North Carolina's past and to experience its scenic diversity and natural beauty.

North Carolina's state historic sites chronicle more than seven centuries, from the early native cultures at Town Creek Indian Mound to the marvels of 20th-century technology showcased at the North Carolina Transportation Museum. Celebrating one of the state's "firsts" is Reed Gold Mine, where the first documented discovery of gold in the United States took place. Tributes to the state's agrarian roots are found at the antebellum plantation at Somerset, the early-20th-century Horne Creek Farm, and the homestead of tobacco magnate Washington Duke. Historic Bath, Historic Edenton, and Historic Halifax reveal aspects of the state's colonial period, as do the ruins at Brunswick Town. Other sites detail epic struggles. Fort Dobbs recalls the French and Indian War along North Carolina's frontier. Alamance Battleground tells of the dramatic climax of the War of the Regulation. The bullet-scarred walls of the House in the Horseshoe are a vivid reminder of the bitter internal struggle during the Revolutionary War, while the CSS *Neuse*, Forts Fisher and Anderson, Bentonville Battleground, and Bennett Place all help portray the story of North Carolina during the final days of the War Between the States. The Charles B. Aycock Birthplace recognizes the contributions of the Tar Heel State's "Education Governor," while the Charlotte Hawkins Brown Memorial honors an individual determined to provide quality education for black students in the 20th century. Other sites honor North Carolina governors Richard Caswell and Zebulon Vance, United States president James K. Polk, and 20th-century author Thomas Wolfe.

All sites are administered by the North Carolina Department of Cultural Resources. For information, contact

North Carolina Historic Sites
Division of Archives and History
Department of Cultural Resources
4620 Mailservice Center
Raleigh, N.C. 27699-4620
919-733-7862/919-733-9515 (fax)
www.ah.dcr.state.nc.us/sections/hs

The intent of this guide is to provide readers with a brief overview of each site, how it came to exist, what to expect when visiting, and the site's location. The sites are listed in alphabetical order within their geographic regions, as determined by the Division of Archives and History. From April through October, site hours are 9 A.M. to 5 P.M. Monday through Saturday and 1 P.M. to 5 P.M. on Sunday. From November through March, the hours are 10 A.M. to 4 P.M. Tuesday through Saturday and 1 P.M. to 4 P.M. on Sunday. All sites have a visitor center. Some visitor centers have museums, exhibit areas, or audiovisual programs. At least one staff member will be on hand at each center to assist guests. All sites offer rest rooms, vending machines, and picnic areas. All have a small selection of souvenir items; some have large gift shops. All sites are free, though some charge a nominal fee for certain activities. Each site holds one or more special programs each year, including "living history" days, anniversary celebrations, encampments, and tactical demonstrations. A calendar of events, available at the beginning of each year, lists the programs and dates at each site; it is distributed at state welcome centers or can be obtained by writing the Department of Cultural Resources. Because of the changing nature of such programs, they are not mentioned among the things to do for the individual sites in this guide.

Explore and enjoy!

Acknowledgments

I extend sincere thanks to the North Carolina Department of Cultural Resources for its assistance with this project and to the individual site managers for their corrections and suggested improvements to the original text. In particular, I am indebted to Dr. Richard Knapp, whose 1995 report on the history and status of each state historic site proved an indispensable aide in the writing of this book. Sincere thanks also go to Chuck Kullmann, without whose help this book would likely have never seen print.

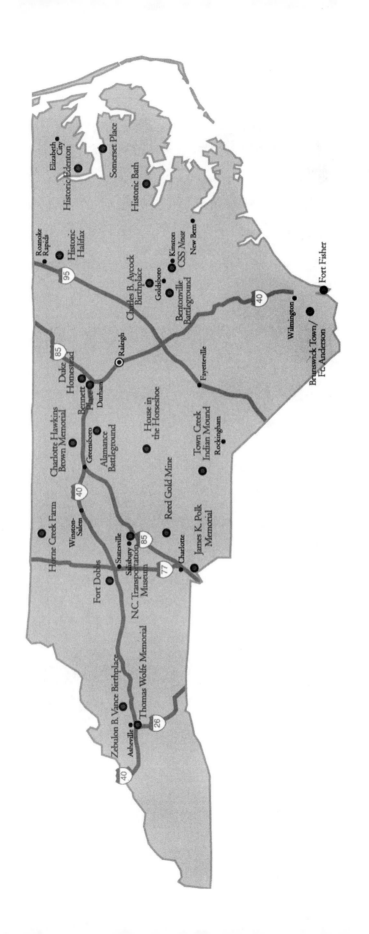

Elizabeth City

Historic Edenton

Somerset Place

Historic Bath

Roanoke Rapids

Historic Halifax

Kinston
CSS Neuse

New Bern

Charles B. Aycock Birthplace

Goldsboro

Bentonville Battleground

Fort Fisher

95

40

Raleigh

85

Duke Homestead

Bennett Place

Durham

Wilmington

Brunswick Town/
Ft. Anderson

Charlotte Hawkins Brown Memorial

Greensboro

Alamance Battleground

House in
the Horseshoe

Fayetteville

Town Creek Indian Mound

Rockingham

40

Hezone Creek Farm

Winston-Salem

Reed Gold Mine

Statesville

N.C. Transportation Museum

85

Salisbury

Charlotte

James K. Polk Memorial

77

Fort Dobbs

Zebulon B. Vance Birthplace

Thomas Wolfe Memorial

Asheville

26

40

ix

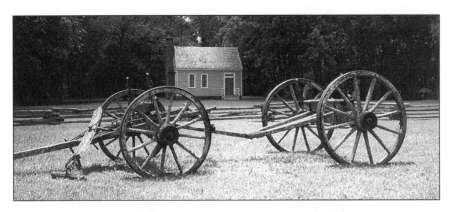

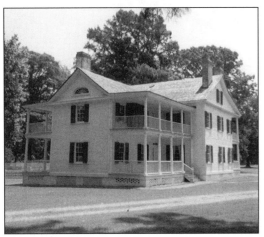

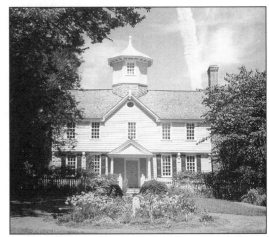

Top: The Burgess Law Office in Historic Halifax. Center left: With its two-story front and side porches, the Somerset Place mansion is the quintessential antebellum plantation house. Center right: The Cupola House in Historic Edenton. Right: Visitors can examine the remains of the CSS Neuse under its new shelter.

Northeast

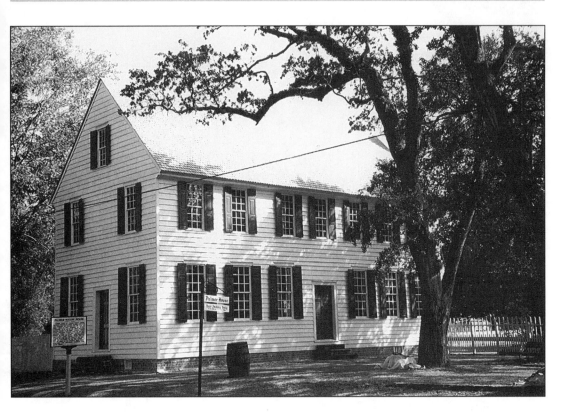

\mathcal{B}ath holds the distinction of being North Carolina's first town. It is home to the oldest church in the state, and it housed the colony's first public library. It gave sanctuary to colonial America's most infamous pirate and was cursed for eternity by one of the leading clergymen of his day. Bath well deserves to be called historic.

Although the first settlements in the province were north of the Albemarle Sound, migration gradually spread south to the Pamlico River. The need for a place where settlers living along this southern frontier could barter or ship their goods was apparent. In 1704, surveyor John Lawson laid out plans for a town at a point where two creeks formed a peninsula with a natural harbor. Named in honor of John Granville, earl of Bath, the town was incorporated March 8, 1705. In 1708, Bath had 12 houses and a population of 50. Although the town never grew large in size, it was a hub of activity for settlers in the region and benefited from being on the first post road connecting the colonies from Massachusetts to Georgia.

Many of the province's earliest luminaries called Bath home. Among them was Lawson, who wrote the first history of the colony (*A New Voyage to Carolina*) and who served as surveyor general of the province. At the outset of the Tuscarora War in the summer of 1711, Lawson was captured by Indians and put to death. North Carolina's coastal plain witnessed two years of bloodshed between Native Americans and European settlers before the Tuscaroras were driven off. Another leading citizen of the period was Christopher Gale, the colony's first chief justice; Gale served in that post on three separate occasions, his tenure spanning 20 years. Governor Thomas Cary lived in Bath, as did Royal Governor Charles Eden.

The most famous—or infamous—of all those who lived in Bath, however, was one who passed through town several times in 1718. His name was Edward Teach, but he was better known as Blackbeard. This fearsome pirate had a short career, from 1716 to 1718, but his wild visage (replete with smoking hair) and unequaled daring (he once extorted supplies from the town of Charleston while his ships blockaded its harbor) made him the terror of the high seas. When King George I offered pardon to anyone who would pledge to cease from pirating, Blackbeard accepted the offer,

receiving his pardon in Bath from Royal Governor Eden. Along with a number of his crew who also accepted pardons, Teach retired to Bath. Tradition has it that he married one of the local women and was likely an accepted member of the small community for the short while he was in residence. Blackbeard still maintained a base of operations at Ocracoke, however, and it is probable that he and his former crew violated their oaths and returned to raiding. Teach was killed in battle on November 18, 1718, while engaging two British ships sent by Virginia's Royal governor, Alexander Spotswood, and commanded by Lieutenant Robert Maynard. The death knell of the Golden Age of Piracy had sounded.

Bath enjoyed periods of importance during the colonial age. When the precinct of Beaufort was established, Bath was the county seat. For many years, naval, collections, and customs officials lived in the village, as did governors and other officials of the province; sessions of the general assembly met in Bath. A bill passed by the lower house of the assembly in 1746 that would have made Bath the capital of the province, however, was rejected by the upper house. Instead, New Bern was chosen as the site for North Carolina's seat of government. The town of Washington later replaced Bath as the seat of Beaufort County. By the 1760s, Bath's importance had passed. Some say it was the re-

sult of a curse placed on the town years earlier. The popular story goes that the Reverend George Whitefield, a firebrand well known for his oratory, paid several visits to Bath. When the minister, one of the leaders of the Great Awakening in the early 18th century, felt that the citizens of Bath had failed to honor their commitments to him, he departed in a fury. Supposedly shaking the dust of Bath from his shoes as he left, he cursed the town to forever be nothing more than a hamlet. Though his anger dissipated (Whitefield made Bath his headquarters in later years), the curse lived on. Today, Bath is a quiet village off the beaten path, hardly noticed by casual drivers. To those who enjoy history, however, it offers a handsome reward.

Site History

In 1955, Bath's 250th anniversary sparked interest

Opposite page: The Palmer-Marsh House, one of North Carolina's oldest homes, is an outstanding example of the architecture of mid-18th-century colonial America. Below left: Now a house museum, the Palmer-Marsh House displays many authentic items from the mid- to late 1700s, such as this elegant secretary. Top right: One of the unusual features of the house is the basement kitchen. Bottom right: The well-tended lawn and garden add to the beauty of the Palmer-Marsh House.

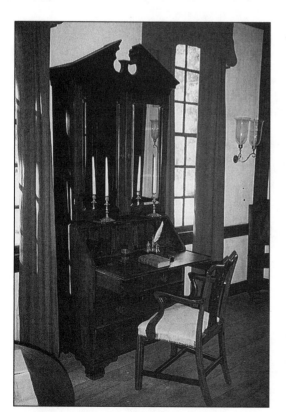

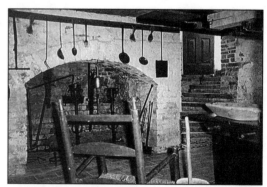

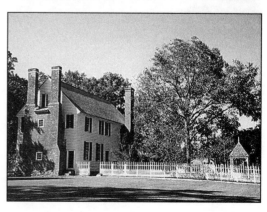

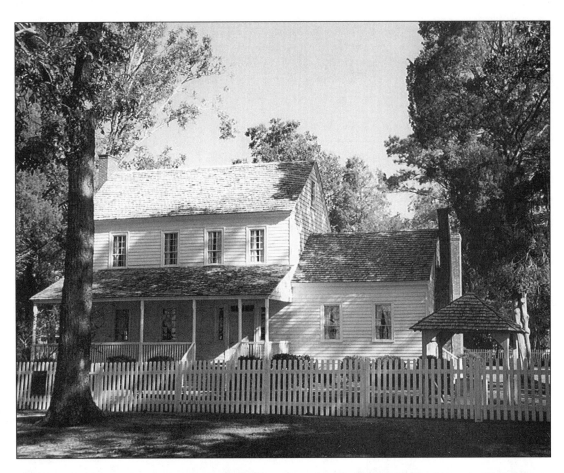

among locals in preserving and restoring the historic town. The Beaufort County Historical Society undertook the restoration of the Palmer-Marsh House in 1958 and the Bonner House in 1959. Also in 1959, the North Carolina General Assembly established the Historic Bath Commission. The Palmer-Marsh House and the Bonner House were opened to the public on May 5, 1962. The following year, the general assembly designated Bath a state historic site. During the 1960s, an old store on Main Street served as the visitor center. It was replaced by a modern center in 1970. That same year, the site acquired the Van Der Veer House. In the decades since that time, Historic Bath has operated through the cooperative efforts of the Department of Cultural Resources (which administers the site), the town of Bath (which oversees zoning for the historic district), the Historic Bath Commission (which assists in the acquisition of property and furnishings), and the Episcopal Diocese of East Carolina (which owns St. Thomas Episcopal Church).

Things to See and Do

The visitor center provides an orientation film on the town of Bath.

Visitors can take a guided tour of the Palmer-Marsh House and the Bonner House. One of the oldest homes in North Carolina, the Palmer-Marsh House was built around 1751 by Michael Coutanch, a merchant and town commissioner. Thanks to its massive chimneys and many windows, the two-story frame house is as impressive today as it surely was when built. In 1764, the house was purchased by Colonel Robert Palmer, collector for the port of Bath, surveyor general of the colony, and member of Governor Tryon's Royal Council. The house is a National Historic Landmark. Overlooking beautiful Bath Bay and shaded by towering pecans and cedars, the Bonner House, constructed 80 years later, is equally impressive. Its original owner, Joseph Bonner, was descended from a prominent Beaufort County family. A farmer, Bonner owned more than 3,000 acres and 33 slaves. The house features many examples of early-19th-century coastal Carolina architecture, including wide pine floorboards, finely carved woodwork, marbleized trim, and small window panes. One bed is detailed with tobacco leaves.

Before or after the guided tour, visitors can walk through the relocated Van Der Veer House at their leisure. While the exterior retains its original appearance, the interior has been remodeled into exhibit rooms. Also open to the public is St. Thomas Episcopal Church, the oldest church building in North Carolina. Although the parish was formed in 1701, work on the small brick church did not begin until 1734.

Ballast stones were used in the construction of the nearly square house of worship. When the parish was given a 1,000-volume collection of books, Bath became home to the first public library in the province.

Address and Location

Historic Bath
Box 148
Bath, N.C. 27808
252-923-3971 / 252-923-0174 (fax)
www.ah.dcr.state.nc.us/sections/hs/bath/bath.htm

Historic Bath is located on N.C. 92 off U.S. 264 east of Washington, North Carolina.

Opposite page, top: Situated at the tip of the peninsula formed by Bath Creek and Back Creek, the Bonner House has an idyllic setting. Bottom: From the porch of the Bonner House, visitors can enjoy a wonderful view of Bath Bay. This page, top: The rustic St. Thomas Episcopal Church is the oldest house of worship in the state. Bottom: The Van Der Veer House contains exhibits chronicling Bath's nearly 300 years of history.

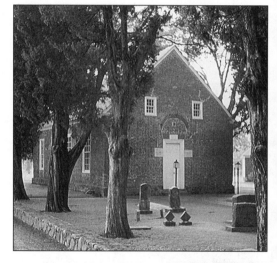

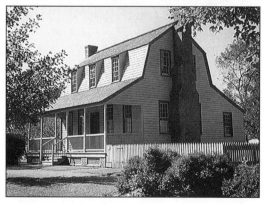

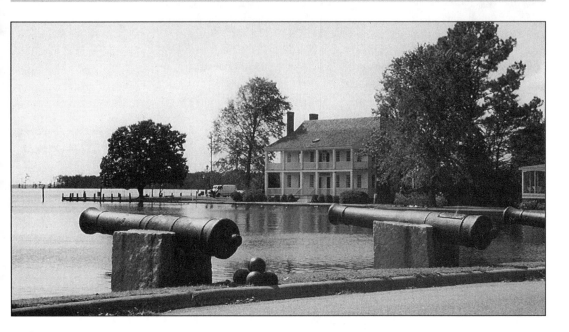

Visitors to the town of Edenton can explore a number of important sites dating to the town's colonial and Revolutionary War periods.

The Albemarle, the first area in the state to be permanently settled, is often called the "Cradle of the Colony." The settlement of Carolina began in the northeastern corner, as colonists started migrating south from Virginia into the area along the Albemarle Sound beginning around 1660. In 1663, King Charles II granted to eight Lords Proprietors the land his father, Charles I, had given to Sir Robert Heath in 1629. Albemarle County, named for George Monck, duke of Albemarle, one of the Lords Proprietors, was established in 1664. It encompassed all the land north of the Albemarle "River" and east of the Chowan River. Covering an area of 16,000 square miles, the county was divided into the precincts of Chowan, Currituck, Pasquotank, and Perquimans.

The colony was slow to grow under the direction of the Lords Proprietors. But by the early 1700s, large, successful plantations were nevertheless thriving in the region. In 1712, the colonial assembly authorized a town to be laid out at the southwestern tip of the county along Queen Anne's Creek, a tributary of the Chowan River. Known for years by its location, the hamlet on Queen Anne's Creek slowly became a center for commerce. Designated the "Port of Roanoke," the town was an official port of entry for the province. It grew in importance politically as well,

owing to the dominance the wealthy landowners of Albemarle enjoyed in the colonial assembly. Additional prestige came when Governor Charles Eden chose to build his home just outside the village around 1718. After the governor's unexpected death in 1722, the town on Queen Anne's Creek, renamed Edenton in the governor's honor, was incorporated, making it the second-oldest town in North Carolina. From 1722 until 1740, Edenton unofficially served as the colony's capital.

In 1712, the province was divided into the colonies of North and South Carolina. In 1729, all but one of the Lords Proprietors, Lord Granville, sold their holdings to the king, after which North Carolina became a Royal colony. By 1740, the eastern region along the Albemarle and Pamlico Sounds was well settled, as was the area along the lower Cape Fear. Gradually, North Carolina's Piedmont also began to be settled, mostly by pioneers moving into the area from points north and south, rather than east. In spite of the shift in population in the decades that followed, political control of the colony still lay in the east, and Edenton continued to exert its influence.

By the mid-1760s, there was political unrest in the colony, as those in the western counties felt, with justification, that they were being victimized by the laws passed by an assembly controlled by eastern landowners. The resulting conflict, known as the War of the Regulation, was not directly related to the American Revolution but nevertheless

foreshadowed the willingness of North Carolinians to fight for a right and honorable cause.

Numerous events took place across North Carolina that put the colony at the forefront of the American Revolution. One that received much attention in England took place in Edenton. A convention comprised of many of North Carolina's most illustrious men met in New Bern in August 1774, in open defiance of Royal Governor Josiah Martin. This august body chose three men—including Edenton merchant Joseph Hewes—to represent the colony at the proposed Continental Congress. It also passed a number of resolutions, including those banning the importation or use of such British commodities as cloth and tea. To show their support of the non-importation act, 51 women of Edenton, supposedly at the invitation of Mrs. Penelope Barker, held a "tea party" at which each lady signed a pledge to support the resolves. This compact was the first known action of a strictly political nature by a body of women anywhere in the colonies. Soon afterward, ladies in Wilmington, North Carolina, took similar action.

The aforementioned Joseph Hewes served the colony in both the First and Second Continental Congresses. Along with William Blount and William Hooper, Hewes was one of the three North Carolinians to sign the Declaration of Independence. He was also a leading proponent of the establishment of a navy for the new nation and was instrumental in enlisting the services of one John Paul Jones.

Other citizens of Edenton who played prominent roles around the time of the American Revolution were Samuel Johnston, Hugh Williamson, and James Iredell. A wealthy planter active in every facet of colonial government and a strong proponent of independence, Johnston served as governor from 1787 to 1789, presided over North Carolina's two Constitutional Conventions, and served as a United States senator. Williamson, a doctor, served as surgeon general of the militia during the war, was twice a delegate to the Continental Congress, was one of three North Carolinians to sign the United States Constitution, and served two terms as a United States congressman. James Iredell began a life of public service early, first serving as deputy collector for the Port of Roanoke. At age 28, he became the state's attorney general, a position he held throughout the Revolutionary War. Iredell worked hard for ratification of the Constitution in 1788 and 1789. President Washington subsequently appointed him to serve as an associate justice on the first United States Supreme Court. He remained on the bench until his death in 1799.

Without question, Edenton was at the apex of its political and commercial prominence during the years leading up to, during, and immediately following the Revolutionary War. In the early 1800s, the town's

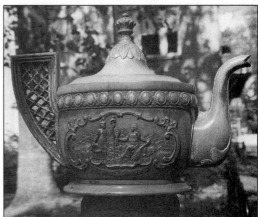

Opposite page: The Barker House is one of the most-photographed homes in North Carolina. This page, left: In the foreground stands the Joseph Hewes Monument; beyond the village green is the Chowan County Courthouse, one of the finest examples of Georgian architecture in the South. Above: In honor of Edenton's famed party, a teapot has been the town's identifying symbol for more than two centuries. This bronze monument was erected near the village green in 1905.

influence began to diminish. Its importance as a port took a setback in 1795, when a hurricane made subsequent navigation of the Roanoke Inlet difficult. The construction of the Dismal Swamp Canal channeled commerce away from Edenton to Norfolk. And new railroads were built west of the Chowan River, leaving Edenton in isolation. Today, the town on Queen Anne's Creek that prides itself on its heritage is a picture of small-town America.

Site History

The James Iredell House was on the market in 1948 and was possibly fated for demolition when the newly formed Edenton Tea Party Chapter of the Daughters of the American Revolution stepped in. It purchased the house and formed the James Iredell Association. By 1951, however, the association could not meet the financial burdens of purchasing, maintaining, and restoring the home and turned to the state for help. The general assembly authorized the Department of Conservation and Development to assume title to the property by paying off the remainder of the mortgage. Subsequently, an agreement was reached whereby the James Iredell Association would continue the immediate task of restoring, furnishing, and operating the house, subject to inspection and approval by the state. Soon, a portion of the house was opened to the public for a small fee. In 1964, a schoolhouse originally located at Bandon Plantation was moved to the back corner of the Iredell property.

By the mid-1960s, five different groups were acting independently to preserve and restore historic sites in Edenton. The Division of Archives and History proposed the establishment of a supervisory agency, to be called Historic Edenton, to coordinate their efforts. The five groups agreed. In 1967, the James Iredell Association entered an agreement with Historic Edenton.

In 1968, the Barker House started service as a visitor center. The position of site manager for the Iredell House was authorized in 1970. The Department of Archives and History and Historic Edenton agreed that the manager's responsibilities would include operating and maintaining all Edenton sites. In 1992, the Ziegler House, adjacent to the Iredell property, was opened as the new visitor center.

Today, the state-owned property includes the James Iredell House—including its kitchen, carriage house, and privy (one of the oldest such structures in the country)—the schoolhouse and dairy relocated from Bandon Plantation, and the Chowan County Courthouse and Jail. When the courthouse was transferred to state ownership in 1996, the site name was changed from James Iredell House State Historic Site to Historic Edenton State Historic Site. Under the umbrella of the Edenton Historical Commission, which replaced Historic Edenton in 1980, are the Cupola House and the Barker House.

Things to See and Do

Visitors touring Historic Edenton will see several of the most recognizable buildings in the state and a number of distinctly different architectural styles spanning centuries.

The visitor center, located on North Broad Street, is a Victorian home remodeled for its new purpose. The slide show at the center provides a succinct overview of Edenton's history, focusing especially on the individuals who helped give the town its place of prominence in the late 18th century. The center has a gift shop well stocked with local crafts, jewelry, collectibles, and books. While at the center, visitors can select from a choice of tours, all of which require a fee. The longest tour is a guided walk covering many town blocks.

A favorite site in Edenton is St. Paul's Church, begun in 1736 but not completed for over 30 years. Colonial governors Thomas Pollock and Henderson Walker and the aforementioned Charles Eden are buried on the grounds of St. Paul's. The picturesque Episcopal church is the second-oldest house of worship in North Carolina.

The Cupola House, a Jacobean home built in 1758 by Francis Corbin, agent for Lord Granville, is among the most readily identifiable structures in North Carolina. The impressive Georgian woodwork

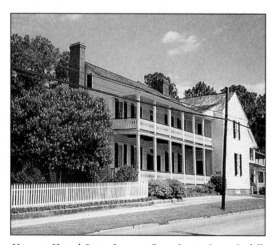

Home to United States Supreme Court Justice James Iredell, this imposing frame house has undergone several additions since his death.

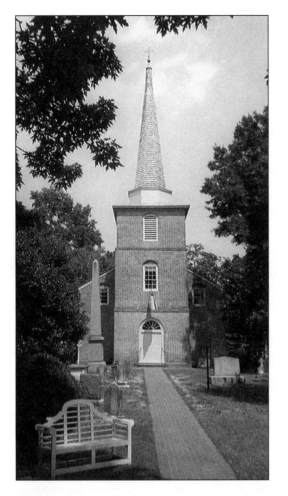

inside has been reproduced to match that removed from the house in 1918. The home is currently a house museum.

The Barker House, relocated from North Broad Street to its current spot on the Edenton Bay, was home to Thomas and Penelope Barker, she of the famous tea party cited above.

Like the Cupola House, the James Iredell House is now a house museum. The home was built in 1800; the house tour provides clear evidence of where an addition was made in 1827. The two-story Federal house is listed on the National Register of Historic Places. On a corner of the Iredell property is a small schoolhouse moved here from Bandon Plantation. This may have been the office where, from the late 1940s until the early 1960s, Inglis Fletcher wrote many of the 12 novels that comprise her acclaimed *Carolina* series, historical fiction spanning the years from Sir Walter Raleigh's first colony to the Constitutional Convention of 1789.

The imposing Chowan County Courthouse commands the village green. Built in 1767, the Georgian structure served the county as intended well into the 20th century. Planners of Colonial Williamsburg studied Edenton's courthouse in detail prior to beginning restoration of that town's public building. Located behind the courthouse, the old county jail, built in 1825, gives visitors a sense of the unpleasant confinement early-19th-century inmates had to endure.

Address and Location

Historic Edenton
P.O. Box 474
Edenton, N.C. 27932
252-482-2637/252-482-3499 (fax)
www.ah.dcr.state.nc.us/sections/hs/iredell.htm

The town of Edenton is located on U.S.17 and N.C. 32 in Chowan County.

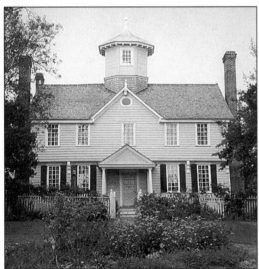

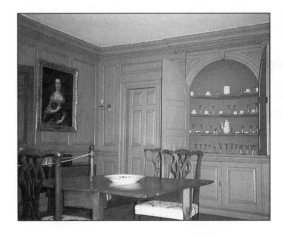

Top left: St. Paul's is the second-oldest church in North Carolina. Above: The Cupola House on South Broad Street is a National Historic Landmark. Right: The dining room of the Cupola House has fine furnishings and highly decorative woodwork, such as a barrel-backed china cabinet.

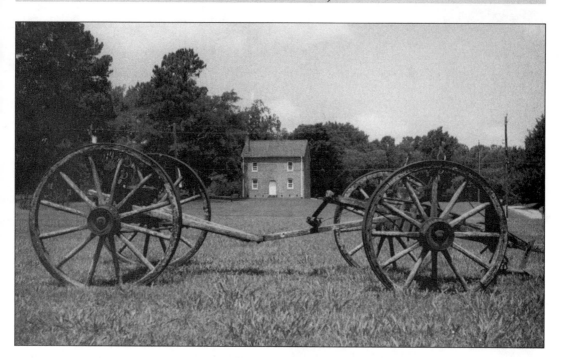

\mathcal{N}amed for George Montagu Dunk, earl of Halifax, the first lord commissioner of trade, the town of Halifax was established in 1760. Situated on a bend of the upper Roanoke River, Halifax was a merchant town ideally situated on the major north-south route between Virginia and South Carolina. The river port quickly grew in prosperity and influence and was the social and political hub of the region. It was home to many of the colony's leading politicians, among them William R. Davie and Willie Jones.

It was in 1776, when the town was host to the Fourth and Fifth Provincial Congresses, that Halifax made its indelible mark on state and national history.

By that spring, ties between Great Britain and its North American colonies had been all but severed. Nearly a full year earlier, guns had been fired at Lexington and Concord; chances for reconciliation grew more faint with each passing day. Nevertheless, Josiah Martin, North Carolina's Royal governor, was confident that the colony would remain loyal to the Crown, especially if a strong British military presence could be arranged. Martin also counted heavily on the support of the large population of Highland Scots along the upper Cape Fear River at Cross Creek (what is now Fayetteville). In the aftermath of their failed effort to place Bonnie Prince Charles on the English throne, the defeated Scots had sworn to protect and defend the English monarchy. Martin's plan was to have them honor their pledge by marching to Wilmington, where they would join British regulars sailing from New York. This show of arms, the governor was certain, would quell any thoughts of rebellion within the province.

Instead, militia units from throughout the colony intercepted the Highlanders at Moores Creek in late February 1776. The battle there was short, fierce, and deadly; the Scots were completely routed.

The battle gave radicals renewed confidence. With the thrill of victory still fresh in their minds, representatives of the Fourth Provincial Congress met in Halifax in early April 1776. Among those present were many of the province's most outspoken revolutionaries. The meeting was specifically intended to provide the three North Carolina delegates to Philadelphia's Second Continental Congress—William Hooper, John Penn, and Joseph Hewes—with instructions on how to proceed. After several days of debate, the Fourth Provincial Congress endorsed a series of resolves, one of which directed the delegation in Philadelphia "to concur with the delegates of the other Colonies in declaring Independency." This was the first action by any legislative body representing a colony to call for independence, giving North Carolina claim to being "first for freedom." April 12, 1776—the date of the Halifax

Resolves, as they came to be known—is one of two dates commemorated on both the state flag and the state seal. Appropriately, the first public reading of the Declaration of Independence in North Carolina was made August 1, 1776, from the steps of the courthouse in Halifax. Cornelius Harnett, president of the Fourth Provincial Congress, had the honor of reading the document.

Halifax also hosted North Carolina's Fifth Provincial Congress, which convened in November 1776. The primary concern of this body was to create a constitution for the new state. Before a constitution could be written, however, representatives felt there was an even more pressing need—that of guaranteeing the rights of individual citizens. After weeks of deliberation, the congress passed both a bill of rights and a constitution. While each had similarities to documents being passed by legislative bodies in other states, they also reflected the demands of North Carolinians for personal freedoms. The state constitution served until 1835.

During the early years of the American Revolution, the major battles were fought in the North, and North Carolina witnessed little action. In 1780, however, the British captured Charleston and made advances into South Carolina's heartland. By late September, troops led by Lord Charles Cornwallis were in Charlotte. Occupying that small town in the North Carolina back country, however, was the high-water mark for Britain's Southern campaign. Following a Loyalist defeat at Kings Mountain and costly battles at Cowpens

Opposite page: The first of the restored buildings in Historic Halifax was the 1838 brick jail, the second story of which served as the public armory. This page, top left: Built in 1832 for $1,600, the County Clerk's Office today houses a representative 19th-century print shop. Behind this office stood the courthouse where the Halifax Resolves were drafted and where the Declaration of Independence was first read publicly in North Carolina. Top right: This 18th-century house, featuring a gambrel roof and dormer windows, belonged to merchant George Owens, Jr. Bottom left: Tradition once held that the Burgess Law Office was where the state's first constitution was written in 1776. Bottom right: The windows and roof of the Tap Room are of the same architectural style as the Owens House.

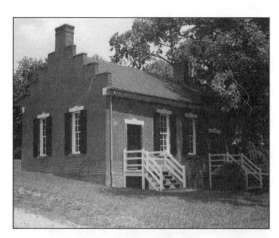

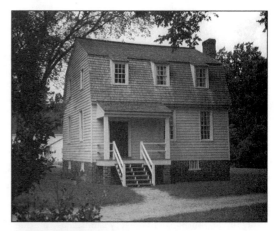

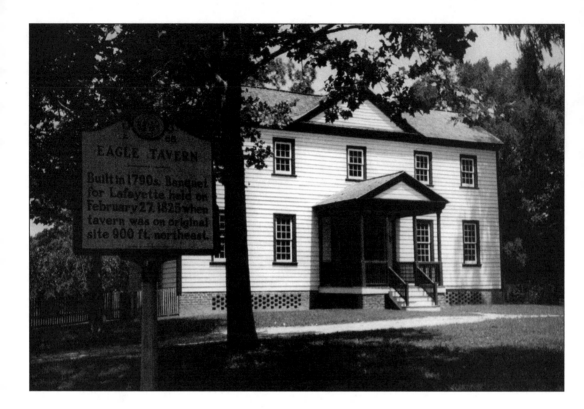

and Guilford Courthouse, Cornwallis's weakened army was forced to withdraw to Wilmington. After several weeks' respite there, the army marched north through the state. For a time, Halifax appeared threatened. The British left the river port largely undisturbed, however, en route to southern Virginia and their ultimate surrender at Yorktown.

The fledgling nation struggled under the Articles of Confederation until 1787, when delegates from the 13 states met in Philadelphia to discuss drafting a new constitution. North Carolina was among the last to ratify the document. Halifax's Willie Jones played a prominent role in opposing ratification. It was not until the national Bill of Rights—very similar to the one passed more than a decade earlier for North Carolina—guaranteed the rights of Americans under the new Constitution that representatives met in Fayetteville in 1789 and approved ratification.

Halifax was one of President Washington's first stops in North Carolina in April 1791, during his tour of the Southern states. He commented in his diary that the town seemed already in decline.

As Halifax's political leaders faded from the limelight, the town's influence waned. The new state constitution of 1835 weakened Halifax even more, shifting power from the eastern counties to the rapidly growing counties of the Piedmont. Halifax's vital role as a river port was diminished when the town was bypassed

by the new railroad lines built in the 1840s. And its agrarian importance ceased with the end of slavery and the old plantation system. Still the seat of the county that shares its name, Halifax is home to only a few hundred people today.

Site History

Early efforts to encourage preservation and restoration of the historic town were initiated by the Halifax Garden Club, led by Mrs. Emily Gary. In 1954, the Historical Halifax Restoration Association was formed. It set about acquiring buildings and land, purchasing the town's jail in 1955; after exterior restoration, the jail served as a museum. By 1956, the association had obtained about 35 acres. At the encouragement of the association, the state became involved with the project in the early 1960s. In 1965, Halifax was established as a state historic site. Five years later, it became the first National Register Historic District in North Carolina.

The years leading up to the country's bicentennial saw progress in the purchase of additional land and the relocation of families living in Halifax's historic area. A visitor center was built, and the Eagle Tavern, the Burgess Law Office, and the Sally-Billy House were moved to the site in time for the 200th anniversary of the Halifax Resolves. In 1976, the new Joseph Montfort Amphitheater hosted the first performance of the outdoor drama *First for Freedom*;

the play has been performed every summer since.

After the bicentennial, work at the site focused on interior restoration of the buildings and the acquisition of appropriate furnishings. In 1984, after years of excavation, the foundation of the Joseph Montfort Home was enclosed by a two-story, Georgian-style "shell" approximately the size and shape of the home that once stood there. This served both to protect the remains and to provide visitors with exhibits pertaining to Joseph Montfort and the archaeological studies still being conducted at the site. More recently, attention was given to the Eagle Tavern's gardens and orchards, other landscaping projects, and the creation of an outdoor exhibit at the river front.

Things to See and Do

Unlike many state historic sites, which can be seen in an hour or two, a proper visit to Historic Halifax requires several hours.

The modern visitor center houses a museum featuring exhibits on a wide range of subjects: Native Americans, colonial trade and currency, fashion, slave life, architecture, and archaeology. It offers a 13-minute slide show entitled *Halifax: Hub of the Roanoke*, which traces the early history of the river port.

The guided tours of the buildings are set up on a somewhat rigid schedule. One tour, which lasts about 20 minutes, takes visitors through the two-story Owens House. This home, built around 1760, was both the residence and the counting office of merchant George Owens, Jr. A second tour, lasting about 30 minutes, takes guests through the Sally-Billy House. This 1808 plantation home features some of the finest examples of dentil molding anywhere in the United States. The third offering is the Center of Town Tour, which lasts about an hour. Visitors are shown the 1838 jail, the 1832 County Clerk's Office, the Burgess Law Office, the site of the original courthouse where the Halifax Resolves were adopted, and the archaeological remains of the Joseph Montfort Home. Montfort was a prominent merchant, the first clerk of court of Halifax County, a member of the colonial assembly, a colonel of provincial troops, and treasurer of the "Northern Provinces" of North Carolina. In 1771, he served as provincial grand master of the Society of Free and Accepted Masons for all the colonies, becoming the only individual to serve in this capacity.

Also located in Historic Halifax are the Eagle Tavern, where Lafayette was entertained during his 1825 tour; the Tap Room, the only survivor among more than a dozen pubs that served Halifax during its heyday; the town common; and the town cemetery. Among the individuals laid to rest there was Justine Nash, the only woman ever married to two men who served as North Carolina governors. At age 14, Justine married Royal Governor Arthur Dobbs, who was in his 70s at the time. After his death, she married Abner Nash. Justine died during childbirth. Years after her death, Nash became the state's second elected governor.

Address and Location

Historic Halifax
P.O. Box 406
Halifax, N.C. 27839
252-583-7191/252-583-9421 (fax)
www.ah.dcr.state.nc.us/sections/hs/halifax/halifax.htm

Historic Halifax, located on U.S. 301 about 25 miles north of Rocky Mount, is easily reached from Exit 168 and Exit 171 off Interstate 95.

Opposite page: The Eagle Tavern has flower and herb gardens on its lot. Below left: Extensive dentil molding is only one of the striking features of the Sally-Billy House. Below right: On display in the children's upstairs bedroom are the rope and trundle beds typical of the day.

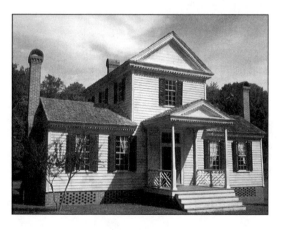

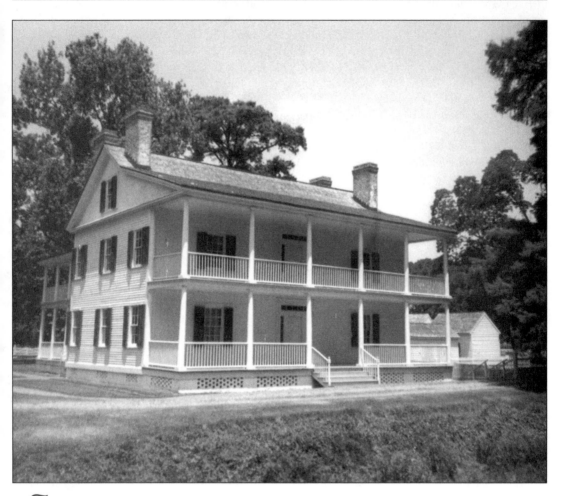

This antebellum plantation is a testament to both the vision of Josiah Collins and his partners and to the accomplishments of his labor force of West African slaves.

In 1784, Collins had an idea that he could develop a successful rice plantation in the marshland along the northeastern shore of Lake Phelps. To do so, he needed two things: a large labor force and a means to transport his product. Collins and two partners in the newly formed Lake Company arranged for 80 slaves to be imported from West Africa. Those slaves set to work digging a six-mile canal that linked Lake Phelps with the Scuppernong River, thus providing the means for transporting the plantation's rice. The task was begun in 1786 and completed two years later.

The West Africans, familiar with growing rice, were able to produce profitable crops within a few seasons. The initial success of the Lake Company allowed the purchase of additional slaves, which meant larger crops, bigger returns, and the purchase of still more workers. Within the first six years of operation, the slave population grew to over 200. By 1816, Collins had bought out his partners and claimed sole ownership of the business, though he never lived at the site. He named the plantation Somerset Place, after his ancestral home in England.

In 1819, upon the death of his father, Josiah Collins, Jr., inherited Somerset. He, too, chose to live in Edenton, rather than on the plantation. It was not until Josiah Collins III acquired the property in 1829 that the plantation actually became a home for its owners.

By that time, over 600 acres of farmland were being cultivated by 200 slaves, making Somerset Place one of North Carolina's largest and most profitable plantations. Collins built a grand three-story mansion near the Lake Phelps shoreline, fronting the canal that was the lifeline for the plantation. Here, Collins, his wife, Mary, and their six sons continued to build the

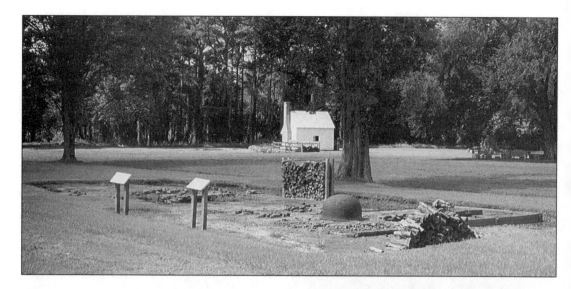

family business. In the years that followed, more than 300 slaves worked 2,000 acres of land. Although he freed no slaves and worked them from sunrise to sunset, Collins tried to provide for his workers. Slave quarters were small but solidly constructed. The workers were well fed, and the plantation provided both a chapel and a hospital.

Everything changed with the Civil War. Josiah and Mary left Somerset Place for Hillsborough, where Josiah died in 1863. Mary returned to her home two years later. Many of the freed slaves who had worked the plantation returned voluntarily. Their labor was no longer free, however, and the widow Collins was unable to meet mounting debts. Although the property was sold to a nephew, this attempt to rescue the plantation failed. By 1870, Mary Collins and her youngest son were alone on the property. Somerset's days of prosperity were at an end.

Site History

In 1889, the plantation was sold out of the Collins family. Over the decades that followed, it passed through numerous owners. In 1939, the state purchased Somerset Place and made it a part of Pettigrew State Park. At that time, the mansion and six outbuildings remained on the site; all were in need of extensive repair. The funds necessary for restoration, however, were not available until the 1950s. In 1965, the North Carolina General Assembly separated the plantation from the park and designated Somerset Place a state historic site. Money was appropriated for continued restoration, and the mansion was furnished with period pieces. Descendants of the Collins family were on hand for the official dedication of the site in 1969. In recent years, the culture and tradition of the

Opposite page: The 14-room Greek Revival mansion dominates the plantation. Center right: The Colony House, once home to the plantation's resident minister and tutors, currently serves as the visitor center. Top: In the foreground are the partially reconstructed foundations of the slave kitchen and outside hearth. In the distance stands a reconstructed slave cabin. Other excavated foundations include the slave hospital and slave chapel. Bottom right: Such dependencies as the smokehouse, salting house, kitchen, and dairy are grouped closely together behind the mansion.

plantation's African community has received increased attention. As a result, Somerset periodically plays host to family reunions of its slave descendants.

Things to See and Do

An original outbuilding serves as the visitor center; no audiovisual program is offered. One room of the center functions as an orientation area. Here, a staff member provides an overview of how the plantation grew from the Lake Company venture into one of the largest family-owned plantations in North Carolina. Visitors are then given a guided tour of the mansion and its kitchen. At their leisure, guests may take a closer look at some of the other original outbuildings, including the dairy, kitchen, smokehouse, and salting house. Some distance removed from these buildings is a reconstructed single-room slave cabin.

Fronting the mansion is the canal; visitors can get a close look at one of the locks.

Address and Location

Somerset Place
2572 Lake Shore Road
Creswell, N.C. 27928
252-797-4650 / 252-797-4171 (fax)
www.ah.dcr.state.nc.us/sections/hs/somerset/somerset.htm

Somerset Place is located in rural Washington County about seven miles south of Creswell, off U.S. 64.

Above: Fronting Somerset Mansion is a small portion of the canal once used to transport produce.

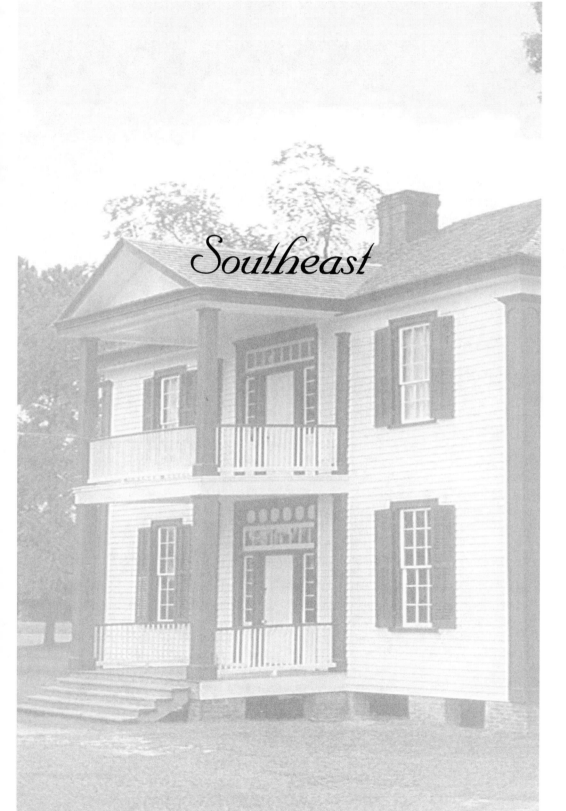

Southeast

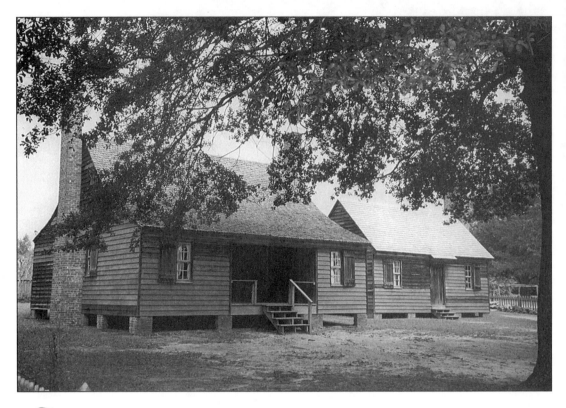

The man remembered as North Carolina's "Education Governor" was born November 1, 1859, northeast of Goldsboro in the rural community of Fremont. The last of 10 children, Charles Brantley Aycock was the son of Benjamin and Serena Hooks Aycock, who married in 1840 and bought land for a farm in Wayne County in 1846.

Although the Aycocks were prosperous—eventually owning over 1,000 acres and 13 slaves to help work them—they were also Primitive Baptists, members of a denomination that believed in simple living. As a result, although they could have afforded more, the Aycocks were content to live in their modest but sturdy frame house. Over time, they added rooms on both sides of the front porch, a room on the back porch, and a separate structure that served as a kitchen and dining room. They also enjoyed the luxury of a live-in housekeeper.

Charles may have been influenced to lead a life of public service by his father, who served as clerk of court for Wayne County and also represented the county in the state senate. After receiving his primary and secondary education in Fremont, Wilson, and Kinston, the young Aycock began studies at the University of North Carolina in 1877. He graduated in 1880, having studied law his last year.

Eighteen-eighty-one proved a year of major change for Aycock. In January, he was licensed to practice law. Soon, in partnership with Frank Daniels, a schoolmate and friend, he opened a law office in Goldsboro. In May, Aycock married Varina Woodard. The couple had three children before Varina's death in 1889. Two years after that, the widower married Varina's younger sister, Cora, a union that produced seven children.

In the meantime, Charles Aycock had begun a civil career. In 1881, he served as superintendent of the Wayne County schools. He also joined the Goldsboro Graded School Board that year; he served on that board for the remainder of his life. In 1893, President Grover Cleveland appointed Aycock United States district attorney for eastern North Carolina, a position he held for four years.

During the gubernatorial campaign of 1896, the Republican and Populist Parties "fused" to elect Daniel Russell. Anxious to regain control of state government in 1900, the Democrats nominated Aycock for the office of chief executive. The Democrats' campaign championed the theme of white supremacy. Aycock

actively supported the party's call for a constitutional amendment requiring that potential voters pass a literacy test before being allowed to cast a ballot. Although the son of a slaveholder, Aycock was determined that the state should provide all children, regardless of race, with a basic education. In part, this deeply rooted belief stemmed from his regard for his mother, who was illiterate. He remembered with embarrassment legal documents marked with an **X** where his mother's signature should have been.

After winning the election, Aycock lost little time in building upon the improvements in education begun by Governor Russell. He traveled from one corner of the state to the other, arduously campaigning for educational advancements. With the support of his brother Benjamin F. Aycock in the state legislature, he made great strides. A system of local taxation to finance the building and equipping of schools was established, to which state funds were added. School districts were consolidated to reduce wasteful spending. School terms were lengthened to four and a half months, and summer schools were started for teacher training. Teachers' pay was increased; teaching requirements were simultaneously raised. Appalachian Normal School (now Appalachian State University) in Boone was established during Aycock's administration, in 1903. Another college proposed while Aycock was governor was established in 1907, soon after he left

office—East Carolina Teachers' Training School (now East Carolina University) in Greenville. More than 1,000 schoolhouses were built across the state during his tenure; the enrollment and attendance for white and black students increased; and illiteracy among both races decreased. Schools for African-Americans, however, remained separate from—and unequal to—white schools. The era is remembered as North Carolina's great "Educational Awakening."

Since he could not seek a second consecutive term as governor, Aycock resumed his law practice in Goldsboro in 1905. In keeping with his Primitive Baptist upbringing, which shunned drinking, dancing, and card playing, the former governor actively supported passage of total prohibition in 1908. The following year, he moved his office to Raleigh, where he continued his practice until his death in April 1912. He was buried in Oakwood Cemetery in Raleigh.

Opposite page: The original main house (left) required extensive repair work; the kitchen is a replica. This page, top left: The two smokehouses in the foreground were acquired around 1960. The privy stands behind them. Bottom left: The corncrib and stable were returned to the Aycock homestead during the early 1960s. Right: Charles B. Aycock served a single term as governor, from 1901 to 1905 (photo courtesy of North Carolina Department of Cultural Resources).

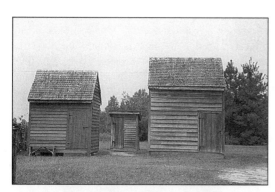

Site History

Although there was interest in establishing a memorial to Aycock as early as the late 1930s, another decade passed before the general assembly created the Charles B. Aycock Memorial Commission in 1949. In 1958, the commission succeeded in having Mrs. Mildred G. Aycock donate the house where the governor was born, plus one acre of land. The state pur-

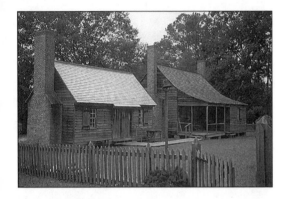

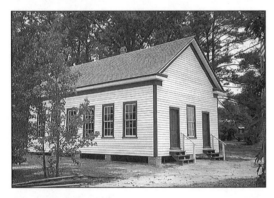

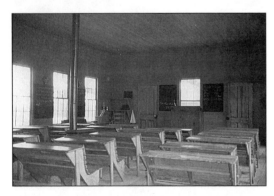

Top: The separate kitchen is divided into two rooms; a dining room occupies half the structure. Center: This single-room schoolhouse is representative of those found throughout rural North Carolina during the last decades of the 19th century. Bottom: Blackboards in such schoolhouses were literally black boards. Classrooms were typically divided, with boys seated on one side, girls on the other.

chased an additional eight acres from Mrs. Aycock at the same time. Soon thereafter, Mrs. Aycock sold three original outbuildings—a corncrib and two smokehouses—to the state. All the buildings were in disrepair. In 1957, the general assembly appropriated $30,000 to complete their restoration. The site was dedicated November 1, 1959, the 100th anniversary of Charles B. Aycock's birth.

The first addition to the memorial was a one-room schoolhouse typical of those in use in the state before Aycock was elected governor. The Oak Plain School was moved from a local community to the site in November 1961. Also in 1961, the general assembly appropriated funds for a visitor center, which was completed the following year. Benjamin Aycock's original stable still stood across the road from the site. In 1963, it was purchased by the state and moved to the site. Except for the addition of an auditorium to the visitor center in 1994, the physical appearance of the site has remained largely unchanged for nearly four decades. In the 1980s, however, the memorial started taking on the appearance of a typical farm circa 1870, as the staff began raising sheep and chickens and cultivating crops, a vegetable garden, and a small orchard.

Things to See and Do

The visitor center offers an audiovisual program and interpretive exhibits that trace the life of Charles Aycock. The emphasis is on his tenure as governor and the improvements made to the state's educational system during his administration. A guided tour of the property includes the main house, the kitchen, the smokehouses, and the barn. Interested parties can sneak a peek inside the privy—a two-seater, very upscale for its day. Also included on the tour is the Oak Plain schoolhouse, built in 1893 and moved to the site from the nearby community of Nahunta; the guide will offer some insight into what rural school life was like during the late 19th century. The site also includes the Aycock family cemetery.

Address and Location

Charles B. Aycock Birthplace
P.O. Box 207
Fremont, N.C. 27830
919-242-5581/919-242-6668 (fax)
www.ah.dcr.state.nc.us/sections/hs/aycock/aycock.htm

The historic site is located outside Fremont off U.S. 117 about nine miles north of Goldsboro.

Bentonville Battleground

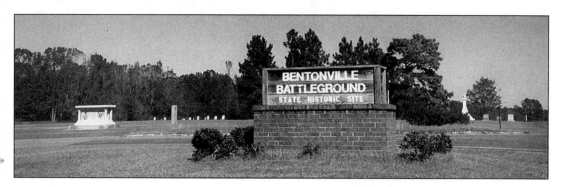

The historic site at Bentonville preserves a portion of the field where, in March 1865, Confederate soldiers under the command of General Joseph E. Johnston mounted a desperate attack upon a portion of the invading Federal army led by General William T. Sherman. The largest battle of the Civil War fought in North Carolina, Bentonville proved to be the last major offensive of the Confederacy.

By February 1865, the Confederate cause was all but lost. Robert E. Lee's Army of Northern Virginia was entrenched in Petersburg, desperately defending Richmond's "back door" and grimly holding off Ulysses S. Grant's numerically superior forces. Elsewhere, the Union onslaught seemed unstoppable. Sherman's March to the Sea effectively divided the Confederacy in two, his scorched-earth policy cutting a swath 40 miles wide across Georgia's heartland. After capturing Savannah in December 1864, Sherman's army drove north into South Carolina in January 1865, where Union troops saw to it that the Palmetto State suffered for having fired the first shots of the war. That same month, North Carolina's Fort Fisher, the last stronghold of the Confederacy, fell to the Federals following a combined land and sea assault. Within weeks, Wilmington was in Union hands, and the last port of the Confederacy was closed.

Into this situation came Johnston, with orders from General Lee to halt the Federal advance. In effect, this meant stopping two armies—that of Sherman, driving north into the Tar Heel Piedmont, and that of General John Schofield, marching northwest from Wilmington. Available to Johnston were the men of General Braxton Bragg's command, recently removed from Wilmington and numbering about 5,500, chiefly the division led by Major General Robert F. Hoke. Joining them were three regiments of North Carolina Junior Reserves, untested 17-year-olds; a makeshift contingent of 5,400 men led by Lieutenant General William J. Hardee; the 4,500-man remnant of Johnston's former command, the Army of Tennessee, now led by Lieutenant General Alexander P. Stewart; and 4,200 cavalrymen commanded by Lieutenant General Wade Hampton and Major General Joseph Wheeler. In total, Johnston's forces massing around Smithfield, North Carolina, numbered around 20,000.

After Sherman captured Fayetteville, he split his forces into two columns, each one numbering about 30,000 men. One column, commanded by Major General Henry W. Slocum, started northeast, toward Dunn. The second, under Major General Oliver O. Howard, moved east, toward Goldsboro. Although Sherman had encountered scant opposition since capturing Savannah months earlier, he nevertheless sought to confound any potential resistance by feinting a move toward Raleigh. His true target was Goldsboro, where he would combine forces with General Schofield and receive much-needed supplies.

This division of the Federal forces gave Johnston an opportunity, however slim, of mounting an offensive against one wing of Sherman's army. But since some his troops had not yet arrived, Johnston needed to gain both time and information. General Hardee provided both.

Under instructions to impede the progress of Slocum's column, Hardee deployed his forces in the vicinity of Averasboro, south of Dunn. Skirmishing between Hardee's pickets and Slocum's advance troops started there on the afternoon of March 15. The following day, the Federals broke through Hardee's first two lines, but the Union advance was halted by the

Above: The three-day action at Bentonville was the largest battle of the Civil War fought on North Carolina soil and the last major offensive of the Confederacy.

Confederates' third line. Under cover of darkness, Hardee's troops were able to steal away. Although the Federals had won the field, Hardee had accomplished his task. By delaying Slocum's advance, he had broadened the distance between the two wings of Sherman's army. Also, he had learned that the true Federal objective was Goldsboro, not Raleigh. This information permitted Johnston to move his troops south from Smithfield to Bentonville and lay a trap for Slocum's column.

Johnston's plan of battle was simple but well designed. Hoke's division, under Bragg, was to form a line across the Goldsboro Road. At a right angle were Stewart's men from the Army of Tennessee. The hinge was to be Hardee's troops, who had not yet arrived from their circuitous retreat from Averasboro. The plan was for the cavalry of Hampton and Wheeler to delay Slocum's advance until Hardee arrived. Then, when the Federals were halted by Hoke's well-entrenched division, Stewart and Hardee would sweep in on the Union left flank, trapping the Federals in a vise.

The battle, begun the morning of March 19, initially went according to the Confederate plan. A Federal division commanded by General W. P. Carlin was indeed halted by the fire from Hoke's men. When two of Carlin's brigades attempted a move to their left in an effort to flank Hoke, they met the withering fire of troops commanded by Stewart. Meanwhile, another of Carlin's brigades made repeated attacks on the right flank of Hoke's line. Although the Federals were repelled at every attempt, General Bragg was concerned that the Confederate line might be overcome. He therefore asked Johnston to send reinforcements. Johnston complied, ordering the first of Hardee's divisions on the scene, that of Lafayette McLaws, to go to Hoke's aid. The support was not truly needed, and the move cost Johnston the opportunity to spring his trap.

Many battles of the Civil War were won or lost by happenstance, and Bentonville was among them. The delay in the arrival of Hardee's two divisions, the er-

ror in sending one of them to a point on the field where it was not needed, and information supplied to the Federals by three Confederate deserters gave Slocum time to bring up reinforcements. In addition, a Union division under General J. D. Morgan, situated on Carlin's right, took advantage of the lull to construct makeshift breastworks.

By the time Hardee's second division, under William B. Taliaferro, arrived, the Confederates' opportunity to squeeze the Federals in a vise had dissipated, as had the element of surprise. The Rebel assault did succeed in routing Carlin's division, but the fortifications hastily erected by Morgan's troops effectively halted the attack. Stewart's and Hardee's Confederates tried repeatedly to advance but were repelled. Hoke's troops joined the attack in the late afternoon, but it was too late to alter the outcome. The Battle of Bentonville was largely over. Some skirmishing took place on March 20, but both the Federals and the Confederates held essentially the same positions as those on the evening of the previous day.

On March 21, Johnston began a systematic retreat across Mill Creek Bridge to Smithfield. Sherman, often vilified for his "total war" philosophy, deliberately sought to avoid further combat. Believing that the war was near an end, he was reluctant for additional blood to be shed unnecessarily by either side. Thus, he was willing to let Johnston's army retreat in peace.

Despite Sherman's orders, a Union division led by Major General Joseph A. Mower attacked the withdrawing Confederates on the afternoon of March 21. Thanks to the spirited fighting of fragmented units of Rebel infantry and cavalry—and Sherman's peremptory order for Mower to disengage—the Union assault fell just short of cutting Johnston's only avenue of retreat.

Whatever satisfaction this brief respite may have afforded William Hardee, responsible for defending the Confederate left, was erased by a devastating personal loss. Hardee's 16-year-old son, Willie, who had only that morning officially signed on as a member of the

Eighth Texas Cavalry, was mortally wounded in the very charge his father led. He died in Hillsborough a few days later, his father at his bedside.

Site History

The 6,000 acres over which the Battle of Bentonville was fought remained entirely in private ownership until 1957. Over the years, a few monuments had been erected, including one memorializing 360 Confederate soldiers buried in a common grave, placed on the site in 1893 by the Goldsboro Rifles, and one placed by the United Daughters of the Confederacy in 1927. Although members of the U.D.C. spent decades campaigning for the preservation and restoration of the battlefield, it was the renewed interest in the Civil War in the years immediately prior to its centennial that finally resulted in action.

In 1957, the North Carolina General Assembly appropriated $25,000 for the purchase of 51 acres, a tract that included the Confederate cemetery, a portion of the breastworks, and the Harper House, used as a field hospital during and after the battle. After the site was purchased, restoration began on the Harper House, a kitchen and slave cabin were reconstructed, and the cemetery and breastworks were cleared of brush and undergrowth. In 1961, the general assembly authorized $26,000 for a visitor center; the Bentonville Battleground Advisory Committee spearheaded a campaign to raise the additional funds needed for its construction. Work began in January 1964. The visitor center was dedicated on March 21, 1965, the 100th anniversary of the end of the largest battle of the Civil War in the state. The center was renovated and new exhibits were added in 1999.

Things to See and Do

The visitor center features an audiovisual program that explains the strategy of the battle and places the engagement in its historical perspective. A small exhibit area includes weapons, equipment, and a fiberoptic map showing the flow of the battle on the first day. Visitors may take a guided tour of the Harper House, which appears as it did when it was pressed into service as a Union field hospital. The rest of the grounds are self-guided; guests may visit reconstructed breastworks, the Confederate cemetery, and a number of markers that help interpret the three-day battle.

Address and Location

Bentonville Battleground
5466 Harper House Road
Four Oaks, N.C. 27524
910-594-0789/910-594-0027 (fax)
www.ah.dcr.state.nc.us/sections/hs/bentonvi/bentonvi.htm

Bentonville Battleground is located on S.R.1008 off U.S. 701 three miles north of Newton Grove. It is convenient from Interstate 40 and Interstate 95; the appropriate exits are marked.

Opposite page, left: A reenactor explains different pieces of equipment to an interested visitor. Right: This memorial to the Confederate dead was placed by the Goldsboro Rifles. This page: The Harper House was used as a field hospital by the Federals during the engagement at Bentonville.

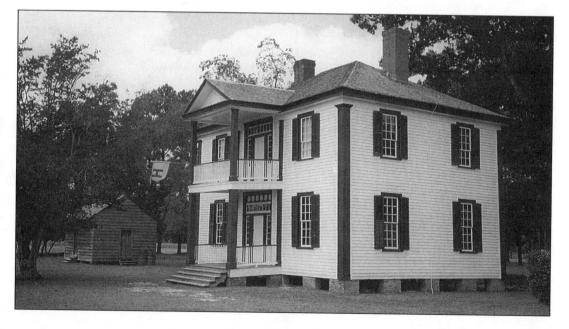

Brunswick Town/Fort Anderson

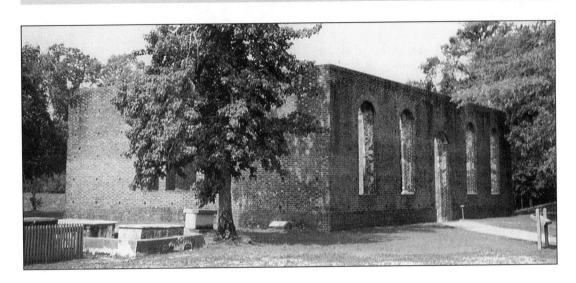

The site at old Brunswick Town commemorates three distinct periods of North Carolina history. One of the colony's earliest ports, Brunswick helped establish the province as a vital source for naval stores. Later, it was the scene of one of the earliest political actions against the Crown in the years prior to the Revolutionary War; at the outset of that conflict, it became one of the war's victims. Nearly a century later, a different war visited the abandoned town site when Confederate troops built an earthen fort in defense of Wilmington at this strategic spot along the lower Cape Fear River.

In 1725, Maurice Moore received a huge land grant along the Cape Fear. Since the colony was in great need of a deepwater port, settlement of the region was encouraged. The town of Brunswick was established in March 1727 and named in honor of King George I, duke of Brunswick. Upon the creation of New Hanover County in 1729, Brunswick was named the county seat. Two years later, it became one of the colony's five official ports of entry. For a time, more naval stores were shipped to England from Brunswick than from anywhere else in the entire British Empire. Although the county seat was moved to Wilmington in 1741, Brunswick became a county seat again in 1764, when Brunswick County was created. From 1758 to 1765, the town was home to Royal Governor Arthur Dobbs, who established Brunswick as the seat of colonial government. Dobbs's estate, named Russellborough, in turn became the home of the governor's successor, William Tryon. During Tryon's administration, the colonial assembly continued to meet in Brunswick until the capital was moved to New Bern in 1770.

Thus, it was in Brunswick that members of the Sons of Liberty openly defied Royal authority by the manner in which they protested the Stamp Act. On February 20, 1766, nearby Fort Johnston was seized by the insurgents, public offices were invaded, and Governor Tryon was held a virtual prisoner within his own home. The leaders of the protesters met on board the British cruiser *Viper* and successfully demanded the release of two merchant ships that had been seized because their cargoes did not carry the required stamps. Later that day, armed colonists coerced promises from customs officials that they would not enforce the Stamp Act in North Carolina. Satisfied that they had won their point, the insurgents returned home. Such open defiance was without precedent anywhere in the colonies, and the success of the venture gave hints of the prominent role North Carolina would play in the coming fight for independence.

A decade after the Stamp Act protest, in the early days of the American Revolution, Brunswick tasted harsh retribution. Royal Governor Josiah Martin's scheme to unite British regulars with a Loyalist army was foiled at the battle of Moores Creek, where nearly 1,000 Scottish Highlanders loyal to King George were soundly beaten by the colonial militia. In retaliation, Sir Henry Clinton ordered British troops under his command to burn Brunswick. Even Russellborough, former home of Royal Governors Dobbs and Tryon but now owned by a well-known Patriot, was destroyed. In the aftermath, few families returned to their

former homes, and Brunswick's life as a town was at an end.

The fury of a different war was felt at Brunswick nearly a century later. When the War Between the States erupted, Federal naval forces closed many of the Confederacy's harbors. As major ports such as Charleston, Savannah, and New Orleans were either captured or closed by blockades, the city of Wilmington assumed increasing importance. With the fall of Mobile, Alabama, in 1864, North Carolina's port city became the Confederacy's last harbor for blockade runners and their desperately needed cargoes. Preventing the Federal navy from closing off the Cape Fear was mighty Fort Fisher, whose guns faced the Atlantic. On the southern tip of the peninsula, some distance removed from the main portion of the fort, was Battery Buchanan, which guarded the actual entrance to the Cape Fear. On the river's western bank about four miles upstream from the northern end of Fort Fisher was the smaller Fort Anderson, built partially over the ruins of Brunswick Town.

Fort Anderson was not tested until after the fall of Fort Fisher. That it, too, would ultimately yield to the Federals was a foregone conclusion, but the three days of resistance the stronghold offered helped ensure the escape of the Confederate army from Wilmington.

Site History

The ruins of Brunswick Town lay largely undisturbed until the site was endangered by the United States government's plan to use the land as a buffer zone for the Sunny Point Army Terminal. Property owner J. Lawrence Sprunt, who also owned nearby Orton Plantation and who had a strong interest in the region's history, instead gave the state a 114-acre tract to be preserved as a historic site. Shortly thereafter, the Episcopal Diocese of East Carolina donated another five acres, which included the ruins of St. Philip's Church.

The state of North Carolina worked out an agreement with the national government that allowed for a buffer zone between the site and the army facility yet still permitted the state to encourage access to the site and build a visitor center within the buffer zone. Dr. E. Lawrence Lee, the historian who had initiated preservation efforts in the 1940s and led an archaeological survey in 1952, was hired by the state in 1958 to make another survey in preparation for extensive archaeological excavation. Staff archaeologist Stanley South began excavation in the summer of 1958. The work continued for more than 10 years. As a result, 23 archaeological features have been cleared for public viewing. The earthworks at Fort Anderson have

been stabilized, as have the walls of the historic church.

Things to See and Do

Brunswick Town is very similar to the sites at Jamestown, Virginia, and Fort Frederica, Georgia. No complete buildings remain in any of these early colonial villages, but archaeological digs have uncovered numerous foundations. At Brunswick, each foundation is marked with an interpretive sign that offers a conjectural drawing as to what the complete structure might have looked like, along with known or probable uses for the building. Enough survives that visitors can get a good sense of the size and scope of the community. Unquestionably, the dominant feature of the site is St. Philip's Church. The walls of the 1754 brick sanctuary are primarily intact. Within them is the grave of Royal Governor Arthur Dobbs. It is possible that Royal Governor William Tryon's young son also lies here.

After strolling the sand streets of old Brunswick, visitors can walk inside the earthworks of Fort Anderson and view the Cape Fear River from atop the fortifications. A series of markers positioned along the earthworks describes the action that took place here.

The visitor center, opened in April 1967, has recently been renovated. It features exhibits and an audiovisual program.

Address and Location

Brunswick Town/Fort Anderson
8884 St. Philip's Road SE
Winnabow, N.C. 28479
910-371-6613/910-383-3806 (fax)
www.ah.dcr.state.nc.us/sections/hs/brunswic/brunswic.htm

Brunswick Town is located midway between Wilmington and Southport off N.C. 133.

Opposite page: The 33-inch-thick walls of St. Philip's are all that remain of the Anglican church built between 1754 and 1768. Below: Ruins such as these are representative of the foundations painstakingly uncovered at Brunswick.

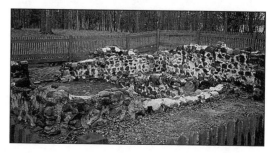

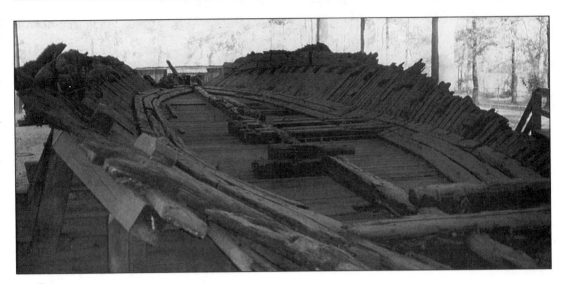

The state historic site in Kinston commemorates two different periods of North Carolina history. The CSS *Neuse* focuses attention on the Confederacy's effort to wrest North Carolina's sounds from Union control by means of a fleet of ironclads. The Richard Caswell Memorial recalls the province's colonial days by honoring one of its leading statesmen, the first elected governor, chosen by the delegates of North Carolina's Fifth Provincial Congress.

The CSS *Neuse* was one of four ironclad gunboats built in North Carolina during the Civil War. Of them, the CSS *Albemarle*, which plied the Roanoke River, had the most success. In April 1864, in a coordinated assault with Confederate ground troops, the *Albemarle* helped the Confederates regain control of the town of Plymouth, sinking the Union ship *Southfield*. The threat posed by the Rebel gunboat made her the target of a daring commando raid led by Lieutenant William Cushing, who succeeded in sinking the ironclad by means of an underwater mine. The gunboat CSS *North Carolina* never saw action, running aground on a sand bar in the Cape Fear River soon after she was completed. When the tide rolled out, the weight of the ship was more than the hull could bear, and the gunboat snapped midship. A second Cape Fear ironclad, the CSS *Raleigh*, saw only limited action, leading a small flotilla in a sortie against the blockading Federal fleet at New Inlet. Following that, the *Raleigh* spent her remaining months guarding the mouth of the lower Cape Fear. Built of timbers from older ships, the *Raleigh* fell victim to sea worms and eventually had to be sunk by her own crew.

Work began on the unfortunate *Neuse* as early as the fall of 1862 at White Hall Landing, 18 miles northwest of Kinston. The *Neuse* was a shallow-draft ironclad ramming vessel 158 feet in length, 34 feet in width; she had a draft of eight feet. Union troops raiding the town on December 13, 1862, found the gunboat under construction but were able to inflict only minor damage. Nevertheless, delays in procuring materials meant that the hull was not completed until late 1863. Then the boat was slipped off her moorings into the Neuse and sent downriver to Kinston, where her boiler, iron plates, armaments, and six-foot bow ram were to be added. Once again, the unavailability of materials and manpower delayed construction for months.

Finally, on April 22, 1864, the *Neuse*, under the command of First Lieutenant Benjamin Loyall, made her first attempt to sail downriver to challenge the blockade at New Bern. She promptly ran aground and remained so for several weeks, until the river rose sufficiently to allow the ram to clear the bar and return to her anchorage, where she sat idle for nine months.

In the spring of 1865, Commander Joseph Price was assigned to the gunboat with orders to employ the *Neuse* in defense of New Bern. He and his crew were never given that opportunity, however, as the Federals had already mounted a campaign to drive into North Carolina's heartland. With Kinston under attack, the crew could do little more than fire a few shots at the advancing Federals before being forced to sink the *Neuse* to prevent her capture by the enemy. An explosion in the bow of the ship sent the last of North

Carolina's ironclad gunboats to her watery grave.

The site also honors one of Kinston's most prominent citizens, Richard Caswell. Born in Cecil County, Maryland, in 1729, Caswell emigrated to North Carolina in 1745. He became the apprentice to surveyor general James McIllwean, his father-in-law. It was McIllwean who introduced the young man to the world of politics. For the remainder of his life, Caswell was actively involved in state government. As a member of the colonial assembly during the late 1760s, he was generally regarded as a moderate and was well thought of by both his peers and Royal Governor William Tryon. During the Regulator movement, Caswell was sympathetic to the grievances of the frontiersmen, but he also stood firmly for the rule of law. As a result, he served as a commander of militia forces supporting Governor Tryon in the Battle of Alamance in 1771, at which time he gained some nominal military experience.

Five years later, he again commanded the militia—this time in opposition to the British. Caswell was credited, along with Colonel Alexander Lillington, with the Patriot victory at Moores Creek Bridge in February 1776. In April of that same year, Caswell was one of the delegates to the Fourth Provincial Congress in Halifax. There, he voted in favor of the Halifax Resolves, the first official call for independence by any colony. Caswell was chosen the state's first governor by the Fifth Provincial Congress, which met in Halifax in November 1776. He served three consecutive one-year terms, during which time he also acted as major general of militia. In 1780, Caswell, General Griffith Rutherford, and a force of 1,200 state militia joined General Horatio Gates and his Continental Army in an effort to halt the British invasion of South Carolina. The Patriots were soundly beaten, due largely to the poor showing of the militia. Throughout the war, Caswell's active participation in state government continued uninterrupted. He served from 1781 to 1784 as comptroller.

Following the Revolutionary War, Caswell once again assumed the responsibilities of chief executive, serving from 1784 to 1787. He was selected by the general assembly to be a delegate to the Constitutional Convention in Philadelphia in 1787. He declined the selection, however, and did not attend the convention due to ill health. A lifetime of public service ended when Caswell was stricken with paralysis while presiding over the state senate in Fayetteville. He died November 10, 1789.

Site History

In the late 1940s, Kinstonians grew concerned that the small cemetery in which Richard Caswell was thought to be buried was being threatened by industrial development. They organized a protective association. Among the leading advocates was attorney John G. Dawson, who in 1955 convinced the general assembly to create the Caswell Memorial Commission and appropriate $25,000 for the purchase of the cemetery. An additional $18,000 in donations was raised by the commission, and the cemetery became state property in 1956. Indecision over the nature and scope of the memorial delayed action for nearly a decade. Finally, in 1966, the small brick building that serves as the Richard Caswell Memorial was opened to the public.

Meanwhile, in 1961, private efforts were initiated to raise the hull of the CSS *Neuse*. Lemuel Houston, H. C. Casey, and Tom Carlyle succeeded in raising the hull above the water by December 1961. Spring floods, however, broke the moorings, and the ram again sank to the bottom. Dan Lilley, chairman of Lenoir County's Confederate Centennial Commission, convinced Kinston's city council and the county commissioners to fund a grant of $9,000 to complete the salvage operation. D. C. Murray, a house mover from Rose Hill, and his crew pulled the *Neuse* from the river in May 1963, despite being hampered by heavy rains.

The gunboat was not yet safe, however, as it was exposed to a year's worth of weather and vandalism before the Caswell Memorial Commission agreed to have the remains relocated to the Caswell site. The hull was cut into three sections, transported, and

Opposite page: The salvaged hull of the gunboat Neuse *is displayed near the river whose name she bore. Since this photograph was taken, the hull has been moved to a new shelter on higher ground. This page: Prior to flooding in 1999, the center's museum exhibited many artifacts from the ironclad and showcased this cutaway model of the Confederate ram.*

rejoined. Governor Terry Sanford allocated $10,000 in emergency funds for that purpose and to pay for a preservative to be applied to the hull. In 1969, an open-air shelter was built. Three years later, a visitor center opened.

For two decades, the park was called the Caswell-Neuse Historic Site. In 1992, in an effort to come up with a more descriptive title, the North Carolina Historical Commission changed the name to the CSS *Neuse* State Historic Site and Governor Richard Caswell Memorial.

Things to See and Do

Even though all that remains of the *Neuse* is her hull, she is nevertheless a rare artifact, being one of only three ironclad Civil War gunboats still extant. (The remains of the Federal gunboat *Cairo* are on display at Vicksburg National Military Park in Mississippi, while the remains of the CSS *Jackson* are exhibited at the Confederate Naval Museum in Columbus, Georgia.) The *Neuse* is on display under a new shelter completed in 1998; guides escort visitors to the shelter and provide general information about the gunboat. An observation platform includes interpretive panels that diagram the layout of the ship. The story of the ironclad is effectively told through exhibits in the museum, including such diverse artifacts salvaged from the gunboat as cooking utensils, personal effects, block and tackle,

percussion shells, grape and solid shot, and the ship's bell. A slide show tells the history of the ill-fated ship and documents the salvage operations that raised the *Neuse* from the river nearly a century after she was sunk.

A separate building houses interpretive exhibits chronicling the achievements of Richard Caswell as a soldier, statesman, and governor. An audiotape provides additional information.

Note: The visitor center was severely damaged by flooding in the aftermath of Hurricane Floyd in September 1999. At present, the Richard Caswell Memorial building is serving as a temporary visitor center. Plans call for a new building to be constructed that will enclose the gunboat and accommodate the visitor center and museum.

Address and Location

CSS *Neuse*/Richard Caswell Memorial
P.O. Box 3043
Kinston, N.C. 28502
252-522-2091/252-527-7036 (fax)
www.ah.dcr.state.nc.us/sections/hs/neuse/neuse.htm

The CSS *Neuse*/Richard Caswell Memorial is located on U.S. 70 (West Vernon Avenue) in Kinston.

Below: This building houses exhibits on North Carolina's first state governor, Richard Caswell.

Fort Fisher

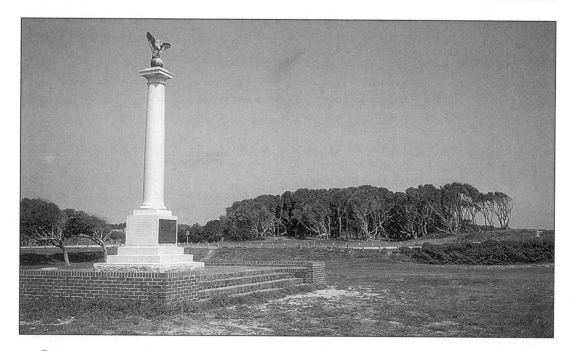

Eighteen miles below Wilmington, at the southern tip of the peninsula formed by the Cape Fear River and the Atlantic Ocean, stand the remains of Fort Fisher, the last major coastal stronghold of the Confederacy. Begun in 1861 and continuously improved over the next two years, this earthwork fort was so strong it was referred to as the "Gibraltar of the South." Fort Fisher justified the comparison, withstanding two naval bombardments (and the dubious threat of a ship rigged as a floating powder keg) before finally succumbing to a land assault.

The entire area was heavily fortified. Guarding the lower Cape Fear at Old Inlet was Fort Caswell, a masonry fort constructed in the 1830s. To strengthen the river defenses, a system of earthen forts was established on Smith Island and both the east and west banks of the Cape Fear. One such fortification was Fort St. Philip, at the site of old Brunswick Town. Placed in command was 26-year-old major William Lamb. The handsome, genial Lamb hailed from Norfolk, Virginia. While in his early 20s, he had worked as the editor of Norfolk's *Southern Argus* newspaper. In 1858, he had formed a militia company named the Woodis Rifles and had been elected its captain. When this militia unit was absorbed into the Sixth Virginia Infantry at the start of the war, Lamb was promoted to major and ordered to Wilmington, where he was to serve as quartermaster for the Cape Fear district. Soon after

his arrival in North Carolina's port city, however, he was transferred to the command of Fort St. Philip. Lamb was an avid reader and a student of military history. In response to his new assignment, he read everything he could find on military engineering and applied what he learned to strengthen his post, which was renamed Fort Anderson. So impressed was his superior that Lamb was promoted to colonel of the 36th North Carolina Artillery and given command of Fort Fisher.

When he assumed his new post on July 4, 1862, the fort, named in honor of Colonel Charles F. Fisher, who had fallen at the Battle of First Manassas, comprised only six artillery batteries mounting 17 guns. Lamb was also surprised upon his arrival to see a Federal gunboat patrolling offshore. Informed that the previous commander had told his gunners not to fire unless fired upon, Lamb was astonished. His first order of consequence was to have the enemy ship shelled. The initial round came near the target, forcing the gunboat to move from harm's way.

Lamb immediately set a goal for himself and his men. As he later recalled, "I determined at once to

Above: Erected in 1932 by the United Daughters of the Confederacy, this memorial stands near the position of Fort Fisher's Pulpit Battery, Colonel William Lamb's command center.

build a work of such magnitude that it could withstand the heaviest fire of any guns in the American Navy." Over the course of the next 30 months, he achieved his goal. Using slave labor in addition to the men of his garrison, Lamb had over 1,000 workers improving Fort Fisher's defenses. Modeled after the Malakoff fortifications in Sevastopol, made famous during the Crimean War, the fort roughly resembled a capital **L** turned upside down. Reaching from the eastern shore of the Cape Fear to the Atlantic Ocean, a distance of about half a mile, was the fort's land face, a series of 16 mounds—called traverses—each about 25 feet in height, between which were placed gun batteries. The workers dug bombproofs (bunkers) under the traverses to safeguard the garrison during bombardments. The land face was protected by a palisade and land mines. In addition, the ground in front of the land face was cleared of trees and shrubbery for a distance of half a mile. At the corner of the inverted **L**, where the land face met the sea face, was a traverse over 40 feet in height, called the Northeast Bastion. Next to this was the Pulpit Battery, Colonel Lamb's command center. Stretching south from this point were the traverses and batteries that formed the sea face. At the midway point of this mile-long sea face was the Armstrong Battery, where Lamb positioned his most formidable weapon, a 150-pounder Armstrong rifled cannon. At the southern end of the sea face was the Mound Battery, an artillery emplacement towering 60 feet. This engineering feat, visible for many miles at sea, was a guide for blockade runners. Since the guns mounted in this battery could easily lob shells onto the decks of Federal ships that ventured too close, Union blockading vessels were forced to keep a safe distance, making it easier for the runners to accomplish their mission. When the work was complete, Fort Fisher was the largest earthwork in the world.

For two years, Fort Fisher went largely untested. Often, shore guns helped blockade runners escape capture by keeping Federal ships at bay. On several occasions, the runner *Ad-Vance* used the protection of the fort to elude pursuit.

At the close of 1864, however, Union strategists agreed the time had come to take Fort Fisher. Toward that end, the largest United States fleet ever assembled to that point in time set course for the Cape Fear, reaching its destination in mid-December. The plan was a coordinated land and sea operation. General Benjamin Butler was in command of the ground assault; Rear Admiral David Porter commanded naval operations. Butler, however, had an idea he wanted to try before any other action was taken. He believed that if

a ship were loaded with gunpowder and exploded near the fort, it would shatter the Confederate stronghold. A flat-bottomed schooner, the *Louisiana*, was selected by Porter to be the "fire ship." "Butler's Pet," as she was nicknamed, was ready on December 23. Although the general was not yet on the scene, Porter decided the window of opportunity had arrived. Escorted by the USS *Wilderness*, the *Louisiana* moved toward her target. With the blockade runner *Little Hattie* unknowingly screening the Federal ship from detection, the *Louisiana* was able to move to within a few hundred yards of the fort's sea face. Fuses were set, the *Wilderness* retired, and the Union fleet waited in the early-morning hours of December 24. The ensuing explosion was spectacular but ineffectual. Other than waking the fort's garrison, the "fire ship" did no damage.

Later that same morning, Porter ordered his fleet to begin shelling. The bombardment lasted over six hours. When it ended, Fort Fisher still stood. A number of gun emplacements had taken hits, but minimal damage was done to the earthen walls and the palisade. Lamb's losses were 61 casualties. Among the attacking fleet, 65 men were killed or wounded, the majority of them by their own malfunctioning weapons. Fort Fisher's ammunition was so limited that Colonel Lamb ordered each gun crew to fire only one round every half-hour. While this made it difficult for the batteries to find and hold their range, their fire was nonetheless remarkably accurate, and many ships took damage.

The following day, Christmas, the shelling resumed and a force of 2,500 Union troops landed north of the fort. The Federals encountered minimal resistance from Confederate soldiers positioned near the landing site. Under the immediate command of Colonel Newton Curtis, the Union troops moved with caution closer and closer to the land face of Fort Fisher. Although the naval bombardment had not resulted in the anticipated damage to the palisade, Curtis's troops were confident that enough gaps existed to allow them to storm the walls. Curtis's superior, Butler, thought otherwise. To their surprise and chagrin, the Federals were ordered to retreat. Their withdrawal marked an end to the first Union attempt to take the fort.

The Confederate garrison received only a brief respite. In mid-January, the Federals returned to launch a second attack. Alfred Terry replaced Butler as army commander. Beginning on the morning of January 13, Porter's fleet pounded the Cape Fear fortification for hours, while its beleaguered garrison could return only token fire. Once more, batteries were damaged but

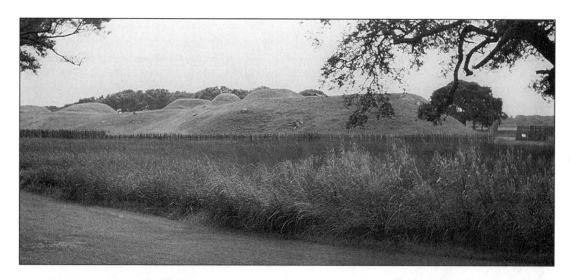

the walls of the fort stood firm. Bombardment continued on January 14 and 15. On the third day of shelling, Union troops commanded by Curtis and Terry were allowed to land uncontested. Confederate general Braxton Bragg, commander of the Wilmington district, inexplicably refused to send aid, essentially sacrificing the fort to the enemy. The Federal land forces were divided in two. One wing, composed of sailors and marines, launched an assault on the Northeast Bastion. The attackers were met by withering fire but still came on. They were challenging the most heavily defended section of the fort, however, and their courageous efforts were in vain. Having sustained heavy casualties, the Union naval contingent was finally beaten back. But the victorious Rebel yell that sounded was short-lived, for just as the Yankees retreated from the northeast corner, Union troops broke through the sally port on the river side of the fort. Upon gaining this foothold, the Federals swept over Shepherd's Battery. From there, the soldiers of North and South fought hand-to-hand. Each battery was contested at great cost to both sides. Since the Confederates lacked

the manpower to stem the tide, the Federals ultimately secured the victory. Fort Fisher, the Confederacy's mighty Goliath, had fallen.

Site History

What the bombardment of the Federal fleet could not do, time and the elements did. Many of the dominant features of the original earthen fort were claimed by the Atlantic Ocean. And when U.S. 17 was built, it traversed the heart of the compound. Efforts to preserve the site began in the 1890s, when Colonel Lamb sought (unsuccessfully) to have the fort made a National Military Park. A marker was placed on the site by the New Hanover County Historical Commission in 1921, and the United Daughters of the Confederacy erected a monument in 1932; otherwise, nothing was

Top: The fort's land face stretched half a mile across the peninsula, from the edge of the Cape Fear to the Atlantic Ocean. Bottom: The reconstructed Shepherd's Battery shows visitors what the fort's gun emplacements looked like prior to the Union assaults.

done to preserve the site. Rather, the outbreak of World War II prompted the construction of a new military base over part of the old fort.

As was the case with other Civil War sites in the state, it was the approach of the war's centennial that rekindled public interest. New Hanover County already owned a half-acre tract that included the U.D.C.'s monument. The state leased 187 acres containing about half of the surviving sea face from the federal government in 1958. The fort was designated a National Historic Landmark in 1961. That same year, and again in 1963, the North Carolina General Assembly allocated money for the construction of a visitor center, which opened in 1965. Three years later, the surviving land-face earthworks were cleared. In the 1970s and 1980s, a gun carriage and a bombproof were reconstructed at Shepherd's Battery and an artillery piece was mounted.

Things to See and Do

The recently refurbished visitor center offers a video program that explains Fort Fisher's role in defending the port of Wilmington and describes the two Federal assaults. The center also houses a museum with interpretive exhibits on the fort's construction, daily garrison life, blockade running, and other related topics. Relics from the fort are on display.

Visitors can tour the grounds on their own by walking a trail that parallels the fort's reconstructed land face. A bridge leads to the sally port, where the attacking Federals first breached the Confederate defenses. Steps lead up to Shepherd's Battery, where a representative artillery piece has been placed. From there, a trail leads behind the earthworks and back to the center. Guided tours of the restored land face are available at regular intervals.

The U.D.C's monument and the New Hanover County memorial stand across the highway in a clearing very near the shoreline.

Address and Location

Fort Fisher
P.O. Box 169
Kure Beach, N.C. 28449
910-458-5538/910-458-0477 (fax)
www.ah.dcr.state.nc.us/sections/hs/fisher/fisher.htm

Fort Fisher is located on U.S. 17 some 18 miles south of Wilmington.

Below: This granite marker, placed in 1921, details the heroic events that took place at Fort Fisher during December 1864 and January 1865. Since the photo was taken, the marker has been moved to a position in front of the U.D.C.'s monument.

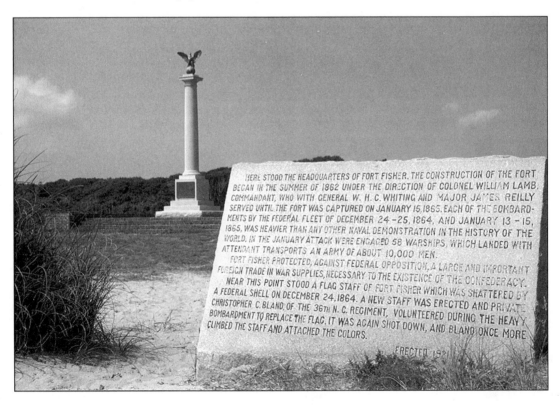

Central

From 1765 to 1771, North Carolina struggled over differences with England and also had to deal with an internal problem generally referred to as the "Regulator movement." At issue was whether citizens in the province's western counties—today's Piedmont region—were receiving the same treatment and protection under the law as those in the east. Part of the friction came because eastern counties were disproportionately represented in the colonial assembly. As more and more people came to live in the colony's back country, representation did not match population. Also contributing to the east-west schism was the fact that the western counties were being settled by immigrants from other provinces, rather than from eastern North Carolina. These newcomers had little affinity for the established, more conservative eastern population. Economics likewise caused a rift. Farmers working small tracts along the western frontier had little in common with the large plantation owners in the east, or with that region's naval and mercantile interests.

These regional differences fostered the Regulator movement and defied efforts to correct them. For any government to work properly, it is incumbent upon the men who execute the laws to be fair and honest. In the eyes of many of those living in the back country, their sheriffs, judges, and tax collectors were unscrupulous individuals who misused their positions for personal gain. Westerners argued that higher taxes were being levied than were appropriate; that collectors were lax in posting when taxes had been paid; that public officials and attorneys charged exorbitant rates for services; and that fees often had to be paid in cash, a requirement especially burdensome to those living on the frontier, where barter, not cash, was the principal means of trade.

Angry voices were heard as early as 1764. Over the next several years, the number of westerners convinced of a need to "regulate" the abuses grew. This loose-knit group of reformers first tried peaceful means to achieve its ends. William Tryon, who succeeded Arthur Dobbs as Royal governor in 1765, seemed to agree that certain abuses were being practiced and indicated that action would be taken to correct them. But the Regulators saw little change. As Tryon's desire to build an elaborate "palace" in New Bern to serve as both his residence and seat of government necessitated even more taxes, the governor further alienated himself from the westerners. The true focus of their wrath, however, was Colonel Edmund Fanning, who controlled Orange County and was considered largely responsible for the abuses.

Hostilities nearly erupted in 1768. The Regulators had sworn oaths not to pay any taxes until their complaints were settled to their satisfaction. Tryon said

that corrective action would be taken but that, in the meantime, the taxes must be paid. When the Regulators threatened to march on Hillsborough and disrupt the trial of two of their leaders, the governor responded by calling forth the militia. He himself traveled to the western counties of Rowan and Mecklenburg to raise men. Both sides had a show of force at Hillsborough, but the trials went on without incident. At their conclusion, the back-country farmers were still expecting that Tryon and the colonial assembly would redress their grievances.

Easterners initially viewed the Regulators as a lawless mob, and sympathy for their cause was slow in coming. By the fall of 1769, however, a few representatives from western counties identified with the Regulator movement had been elected to the colonial assembly. The assembly introduced legislation to resolve many of the fundamental complaints raised by the frontier counties. Unfortunately, it also sought to address grievances between the colonies and the Royal government, and Tryon felt obliged to dissolve the legislature. In the winter of 1770-71, the assembly finally passed legislation aimed at correcting matters in the back country, but an ill-timed show of force by the Regulators at that precise juncture again turned the assembly against them. The harsh Johnston Act was passed in an attempt to curb the growing power of the Regulators and their propensity for lawless behavior.

After years of petitioning with little apparent result, the Regulators tired of waiting and began using violence to get satisfaction. In Orange, Anson,

Opposite page: From the shelter covering one of the site's illustrated markers, visitors can view a major portion of the field of battle. Above: What is now called the Regulator Column was once referred to as the James Hunter Monument. Hunter was one of the prominent figures of the reform movement. Left: This plaque on the Regulator Column details the numerous actions between 1773 and 1776 that put North Carolina out front in the fight for independence.

Edgecombe, and Johnston Counties, they interrupted court sessions, damaged property, and threatened or physically assaulted public officials. Such activities eroded much of the support the Regulator movement had sought. Governor Tryon felt not only compelled to put an end to the lawlessness, but to do so before his pending appointment as governor of New York.

In March 1771, Tryon called for volunteers for the militia. By April, he had a force numbering about 1,100. Meanwhile, General Hugh Waddell recruited a small force of about 300 in the western counties of Mecklenburg and Rowan. The plan called for Tryon and Waddell to meet in Hillsborough. Waddell's men were in the heart of Regulator country, and their efforts to march to Hillsborough were easily impeded. A small band of young men blackened their faces and raided Waddell's supply train, blowing up a wagon of gunpowder that had been sent from Charleston at Tryon's request; history remembers these youths as "the Black Boys of Cabarrus." On May 9, Waddell led his men across the Yadkin River, but upon encountering a considerably larger force of Regulators, he quietly withdrew to Salisbury.

Tryon, meanwhile, had marched his troops to Hillsborough. Learning of Waddell's predicament, the governor led his colonial militia farther west. On May 14, they camped along the banks of Alamance Creek. The main body of Regulators, numbering over 2,000, was only a few miles away. These men were poorly armed, untrained, and without any real leadership. For example, Herman Husband, who had written numerous petitions and tracts in support of the reform movement, was a Quaker and was opposed to violence. And Rednap Howell, a schoolmaster with a knack for making barbed rhymes, was skilled at fighting with words, not weapons. William Butler and James Hunter were also in the forefront of the movement, but neither assumed a position of command. With battle imminent, Hunter stated, "We are all freemen, and everyone must command himself."

On the morning of May 16, 1771, Tryon formed his militia along battle lines. The Regulators responded to his final demand to lay down arms with a haughty "Fire and be damned!" The governor then ordered the militia to open fire. When his troops hesitated, an infuriated Tryon called out, "Fire! Fire on them or on me!" The militiamen did indeed fire upon their estranged countrymen. The Regulators responded, and the fight began. Although disorganized and undisciplined, the frontiersmen fought the militia to a standstill for more than an hour. At one point, some of the Regulators actually succeeded in capturing one of the

eight cannons the militia had brought to the field. Eventually, however, the better-equipped and better-organized militia beat off the insurgents. Tryon's forces counted nine dead and 61 wounded. One captured farmer, James Few, was hanged the following day to show that further resistance would be dealt with harshly. Though Tryon offered pardons to most who had participated, 12 captured Regulators were tried in Hillsborough in June; six of them were executed on the gallows. By this time, however, the Regulators' power was already broken.

While the Regulator movement ended at Alamance, there were important ramifications. First, especially in the Northern colonies, the battle was seen to demonstrate the willingness of men to take up arms to oppose what they saw as injustices in government. Second, when representatives met in the fall of 1776 to draft North Carolina's first constitution and bill of rights, those from the western counties made certain that safeguards were included to prevent the kinds of injustices the Regulators had opposed.

The great irony of the Regulator movement was that many of the rebels who fought against the government in 1771 were counted among the Loyalists

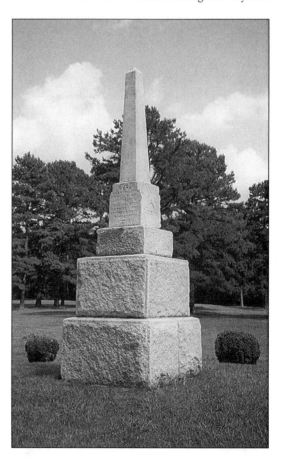

during the Revolutionary War. Having pledged to remain loyal to the king as a condition of their pardons, they were reluctant to go back on their word. Conversely, many of those who had sided with the Royal governor in the earlier conflict were at the forefront of the fight for independence.

Site History

Artist Benson J. Lossing visited the battleground and included a sketch of the field in his illustrated history of the American Revolution. Citizens of Alamance County erected a granite monument on the grounds in 1880. Efforts begun by the Daughters of the American Revolution in the 1940s to preserve the site resulted in the county's deeding a 40-acre tract to the state in 1952 for development as a historic site. In 1955, a site manager was hired, the site was cleared, and new markers describing the events of the battle were placed on the grounds.

In 1957, the North Carolina General Assembly appropriated half the cost of a visitor center, to be matched by the citizens of Alamance County. The building was completed in 1960, and Alamance Battleground State Historic Site was dedicated on May 16, 1961, the 190th anniversary of the battle. The following year, the Regulator Column was moved from the National Military Park in Greensboro to Alamance. In 1966, the John Allen House, a log dwelling typical of the homes in the Carolina back country at the time of the Regulator movement, was moved to the site.

Things to See and Do

The small visitor center across the street from the battlefield features a 20-minute video detailing the reasons behind the Regulator movement and the climactic battle at Alamance. A short distance from the center is a single-room log dwelling with a loft. Built around 1780, it was moved to the site from the nearby community of Snow Camp. The house belonged to John

Allen, whose wife, Amy, was the sister of Herman Husband.

On the opposite side of the highway is the field where most of the action took place. Under a wooden shelter is a large tablet—part of the state's system of highway historical markers—that gives a detailed account of the battle. Two monuments are focal points on the field. The first is a simple granite marker erected in 1880 by the citizens of Alamance County. It was commonly held at the time that the fighting by the Regulators in 1771 gave Alamance claim to having been the first battle of the American Revolution, and the monument is so inscribed. The Regulator Column stands nearby. It was moved to its current location in 1962 from Guilford Courthouse National Military Park in Greensboro, where it was erected in 1901. A tablet on the base of the monument summarizes the activities between 1773 and 1776 that put North Carolina at the forefront of the fight for independence.

Address and Location

Alamance Battleground
5803 N.C. 62 South
Burlington, N.C. 27215
336-227-4785/336-227-4787 (fax)
www.ah.dcr.state.nc.us/sections/hs/alamance/
alamanc.htm

Alamance Battleground is on N.C. 62 in Burlington six miles southwest of Exit 143 off Interstate 85/Interstate 40.

Opposite page: The first memorial on the battlefield was this 13-foot granite monument erected in 1880. Above left: A replica of a three-pounder cannon is located on the grounds. Two cannons of this type were used by Tryon's militia during the two-hour engagement. Above right: The John Allen Cabin exemplifies the type of home found along North Carolina's frontier during the Regulator era.

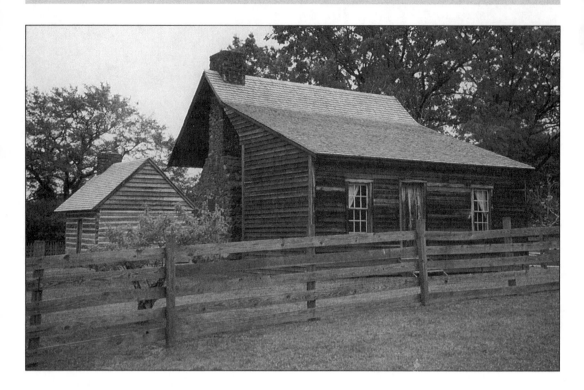

\mathcal{R}obert E. Lee's surrender to Ulysses S. Grant on April 9, 1865, at Appomattox is generally regarded as the act that ended the Civil War. In truth, a larger surrender of Confederate forces occurred in Durham, North Carolina, more than two weeks later. Appomattox has become so much a part of our culture that few people know that Lee did not go to that small Virginia town intending to surrender, but rather to escape the pursuing Federals. Many are surprised to learn that fighting actually occurred at Appomattox and that it was only after Lee failed to break through the Union lines surrounding him that he agreed to capitulate.

By contrast, General Joseph E. Johnston, commander of all Confederate forces in the Carolinas, Georgia, and Florida, came to Durham to surrender. In doing so, he yielded an army, scattered across four states, of nearly 90,000, more than three times the number Lee had under his command at Appomattox. Moreover, Johnston's army was not entrapped and could have fought on. To Johnston's credit, he chose to end the bloodshed by seeking an honorable peace.

Confirmation of Lee's surrender found Johnston's army encamped in the vicinity of Hillsborough. William T. Sherman's Federals occupied Raleigh. Jefferson Davis and his cabinet were fleeing Virginia and heading through North Carolina's Piedmont. Johnston and Davis were able to discuss the situation April 12, when the Confederate president and members of his cabinet were in Greensboro. Davis was convinced that the war could be continued. Johnston tried in vain to persuade him otherwise. The following day, supported by all cabinet members except Secretary of State Judah Benjamin, Johnston finally convinced Davis to permit him to initiate peace talks with Sherman.

Subordinates arranged the first meeting, to be held at noon on April 17 at a point roughly midway between the two camps. Sherman arrived at Durham Station by train, then rode by horseback to meet his Confederate counterpart. Johnston suggested that the two might talk over matters in a small farmhouse he had just passed. Sherman agreed, and the two became the unexpected guests of James Bennett (or Bennitt). The Bennetts had not been spared the horrors of war. Both of their sons and a son-in-law had died during the conflict. Astonished by the appearance at their home of two of the highest-ranking officers of the war, the Bennett family agreed to let them use the farmhouse for the meeting, while they retired to the separate kitchen.

Before Sherman began discussing possible peace

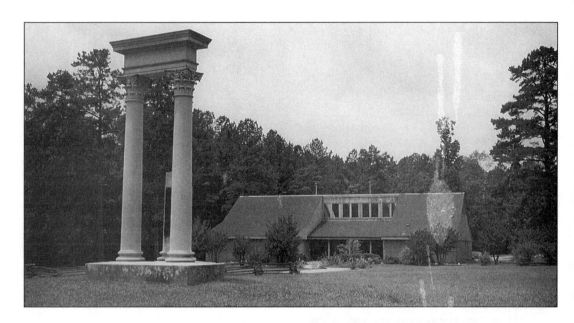

terms, he shared with Johnston the sobering news of President Abraham Lincoln's assassination. The Confederate general received the report with shock and remorse, realizing that the death of Lincoln would likely have unwelcome repercussions for the South. After lengthy discussion, the two men agreed to meet again the following day. Johnston wired Davis, by then in Charlotte, asking that Secretary of War John C. Breckinridge come to Durham to join the negotiations.

The meeting on April 18 did not begin until late afternoon. By its conclusion, conditions for surrender had been drafted. The terms of the agreement signed by Johnston and Sherman called for the disbanding of the Confederate army, the recognition of the state governments, the reestablishment of federal courts, the guarantee of political rights, and a general amnesty for all individuals involved in the rebellion. Sherman was a proponent of these liberal terms in hopes that they would curtail the formation of guerrilla bands. He was also acting in accordance with the desires of President Lincoln, as he had understood them during a meeting the two men had attended at City Point, Virginia, in late March.

Jefferson Davis, receiving a copy of the document while still in Charlotte, reluctantly agreed to the terms. Lincoln's successor, President Andrew Johnson, did not. General Grant conveyed news of the rejection to Sherman on April 24, with an explanation that Sherman had not been authorized to determine civil matters. After receiving additional instructions from Grant, Sherman arranged a third meeting with Johnston at James Bennett's farm. There, on April 26, new terms were signed. They were essentially the same as those given

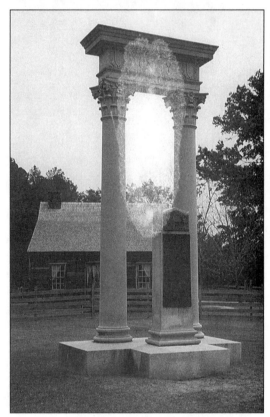

Opposite page: The reconstructed Bennett farmhouse and kitchen were dedicated in 1962, at the height of the nation's interest during the Civil War centennial. Top: The visitor center, opened in 1982, is the newest addition to the site. Above: The Unity Monument focuses attention not upon the Southern surrender at Bennett Place, but upon the reuniting of the nation that resulted.

Top: Exhibits in the center's museum help explain North Carolina's many contributions to the Confederate cause. Center: The main room of the Bennett home is furnished as it was when Johnston and Sherman met on April 17, 1865. Bottom: Typical cast-iron cookware is neatly arranged on the stone hearth of the reconstructed kitchen.

to Lee, and void of any references to civil matters.

Although the surrender of smaller Confederate units in the West continued through May, Johnston's signing of the revised surrender agreement essentially ended the war east of the Mississippi.

Site History

The Bennett family continued to work the farm during the difficult years of Reconstruction. James Bennett died in 1878 and his widow in 1884. After that, their daughter, Eliza Anne, and her three children remained on the farm. In 1889, James Bennett's granddaughter, Roberta, and her husband acquired the property. They sold it the following year to Brodie Duke, the son of Washington Duke, after which the Bennett family left the homestead for Durham. For the next three decades, the farm was left deserted.

In 1921, the farmhouse was destroyed by a fire believed to have been inadvertently started by itinerants. Two years earlier, the property had been bought by Samuel T. Morgan of Richmond, who intended to develop a park on the site. But Morgan died before any action was taken. Durham's R. O. Everett, a member of the general assembly, took up the cause, convincing Morgan's heirs to donate the homesite and three and a half acres of land.

The general assembly established the Bennett Place Memorial Commission, which Everett chaired. The commission had the responsibility of maintaining the property and erecting a monument to commemorate the historic events at the farm. Placed in 1923, the Unity Monument emphasized the restoration of the country that Generals Sherman and Johnston helped bring about. A stone bandstand was moved to the site

from a park in Durham. After that, the site remained virtually unchanged until the late 1950s.

The approach of the Civil War centennial prompted individuals from around the country to raise funds for the reconstruction of the house and kitchen. By good fortune, a Durham house was located that was very similar in age, size, and layout to the original Bennett home. Since that house had been condemned, its owner donated it to the state, and it was transported to the site. While the house was being restored at its new location, a separate kitchen was constructed. Bennett Place was established as a state historic site in 1961. The restored house and kitchen were dedicated in 1962. The following year, a period smokehouse was acquired and moved to the property. Still, Bennett Place lacked a visitor center. A trailer served in that capacity during the 1970s. It was not until 1982 that the current center was built.

Things to See and Do

The focal point of the site is the farmhouse, painstakingly reconstructed to look as the original Bennett home did when it was used by Generals Sherman and Johnston for their historic meetings. The house and kitchen are both included on guided tours. Visitors may tour the site's other points of interest at their leisure or stroll along a portion of the old Hillsborough Road, which passes between the house and the stone bandstand. The visitor center houses exhibits and artifacts detailing North Carolina's role in the Civil War. The audiovisual program *Dawn of Peace* is shown on a regular schedule in the small theater at the center.

Address and Location

Bennett Place
4409 Bennett Memorial Road
Durham, N.C. 27705
919-383-4345/919-383-4349 (fax)
www.ah.dcr.state.nc.us/sections/hs/bennett/bennett.htm

Bennett Place is on Bennett Memorial Road in Durham, just off Interstate 85.

Below, top left: Reenactors await the arrival of the principals. Top right: General Johnston and his staff ride up the old Hillsborough Road. Bottom left: Generals Sherman and Johnston greet. Bottom center: Federal guards keep post. Bottom right: Confederate secretary of war John C. Breckinridge reads the terms of surrender offered by Sherman, while the stoic Johnston listens quietly.

The Charlotte Hawkins Brown Memorial in Sedalia is the first and only North Carolina state historic site to honor an African-American or a woman.

Born June 11, 1883, in Henderson, Charlotte Hawkins was the daughter of Caroline Hawkins and the granddaughter of slaves. At age six, she moved with her family to Cambridge, Massachusetts, where she completed her elementary and secondary education. By a happy coincidence, she came to the attention of Alice Freeman Palmer, former president of Wellesley College and the wife of a Harvard professor. Palmer noticed the girl reading Vergil while taking a young child she was baby-sitting for a stroll. The educator took an interest in Charlotte and assisted her studies at the State Normal School of Salem, Massachusetts.

In 1901, Charlotte Hawkins returned to her native state to assume a teaching position at Bethany Institute in Sedalia, a school founded in 1870 by the American Missionary Association to provide vocational and liberal-arts education to African-American students. She accomplished much during her first year. The church that housed the school proved too small for the 50 students. The enterprising 18-year-old teacher managed—with the help of students, parents, and others in the community—to convert a nearby blacksmith shed into a workable schoolhouse, complete with dormitory space on the second floor for Hawkins and 15

girls. Soon, Hawkins acquired an old house, which was transformed into a boys' dormitory. As the new dormitory was superior to the accommodations above the schoolhouse, Hawkins soon made it coeducational, with boys downstairs and girls upstairs. Despite this progress, however, the American Missionary Association closed Bethany Institute in 1902.

Charlotte Hawkins, not yet 20, determinedly reopened the school in the fall of that same year. She later renamed it the Alice Freeman Palmer Memorial Institute, a tribute to her mentor and benefactor. For the next 50 years, Hawkins served as president of the Palmer Memorial Institute.

In 1911, she married Edward S. Brown, who for a time taught at the school and helped with its administration. Brown, however, felt that the institute was his wife's calling, not his. He left Palmer to take a teaching position in South Carolina. Although the couple eventually divorced, Charlotte continued to use her married name for the rest of her life.

Under her leadership, Palmer Memorial Institute grew in size and reputation. The school became a nationally recognized preparatory school for black students and was fully accredited by the Southern Association of Colleges and Secondary Schools. During her tenure, over 1,000 students graduated from Palmer. In later years, more than 90 percent of the

students went on to attend college, and nearly two-thirds of those sought graduate degrees. Charlotte was concerned not only that her students achieve academically, but that they command the social graces as well. In 1941, she authored *The Correct Thing to Do, to Say, to Wear*, which became required reading for her pupils. Moreover, students were expected to adhere to a strict code of conduct, to dress for dinner, and to observe curfews. Female students were even required to host a tea social for Charlotte at her home prior to graduation, at which time the educator evaluated their etiquette.

Charlotte Hawkins Brown retired in 1952 but remained with the institute until 1955 as its director of finance. She later moved to nearby Greensboro, where she died in 1961. Fittingly, she was buried on the campus of Palmer Memorial Institute. The school continued for another 10 years, but disaster struck when the Palmer Building, the hub of the campus, was destroyed by fire. This, coupled with financial concerns and a

Opposite page: The home of Charlotte Hawkins Brown was called the Canary Cottage by her students because of its yellow color and the educator's pet canaries. This page, top left: One of the two men's dormitories on the campus was Charles Eliot Hall. Bottom left: Kimball Hall served as the dining hall. Right: Shaded by massive oaks, Galen Stone Hall, built in 1927, was the dormitory for women students.

changing educational environment, led the school's board of trustees to close Palmer after nearly 70 years of service to black students across the state.

Site History

After Palmer Memorial Institute closed, the property was purchased by Bennett College. In 1980, the main campus and its surviving buildings were sold to the American Muslim Mission, which attempted to establish a teachers' college. Two years later, Maria Cole, a niece of Charlotte Hawkins Brown, visited a friend and former schoolmate, Marie Gibbs, who was living in Greensboro. A nostalgic trip to the old campus inspired them to try to preserve the decaying campus as a memorial to the black educator. After gaining the support of other Palmer alumni, the two women met with the Department of Archives and History to discuss options. In 1983, State Senator William Martin of Guilford County led the passage of a bill in the general assembly that initiated planning for the memorial; additional funds for a study were granted the following year. The Charlotte Hawkins Brown Historical Foundation also came into existence around this time. In 1985, the general assembly appropriated $400,000 for the purchase of the 40-acre campus from the American Muslim Mission and for the initial restoration of the buildings. The memorial opened as a state historic site in November 1987. The Carrie M. Stone

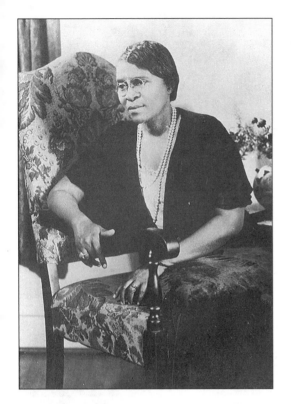

Cottage was restored for use as a visitor center. Charlotte Hawkins Brown's home, known by students as the Canary Cottage, was repaired and furnished, while other campus buildings were stabilized.

Things to See and Do

The visitor center offers a short video summarizing Charlotte Hawkins Brown's efforts to provide black students in North Carolina with a school that would prepare them for successful lives. A small exhibit room features vintage photographs of Brown and campus scenes covering nearly 70 years. A staff member conducts tours of the adjacent Canary Cottage, Brown's former home. For the most part, visitors are free to walk the campus, which includes Kimball Hall (the dining hall) and Galen Stone Hall (the women's dormitory), both built in 1927; the 1929 Tea House and Recreation Hall; the 1968 Stouffler Hall (the science building); and the two men's dormitories, Charles Eliot Hall and Reynolds Hall, built in 1934 and 1968, respectively. The ruins of the Palmer Building, which housed administrative offices, an auditorium, and classrooms, are at the center of the campus. Palmer's bell tower stands a short distance away. Wayside interpretive signs tell the history of the major buildings. Midway between the Palmer Building's ruins and the Canary Cottage is the grave site of the school's founder.

Address and Location

Charlotte Hawkins Brown Memorial
P.O. Drawer B
Sedalia, N.C. 27342
336-449-4846/336-449-0176 (fax)
www.ah.dcr.state.nc.us/sections/hs/chb/chb.htm

The Charlotte Hawkins Brown Memorial is in Sedalia, which lies roughly midway between Greensboro and Burlington on U.S. 70.

Top left: Charlotte Hawkins Brown devoted her life to providing black students with quality education (photo courtesy of North Carolina Department of Cultural Resources). Bottom left: The bell tower was the institute's most recognizable symbol. Above: Now the visitor center, the Carrie M. Stone Cottage (1948) was originally a teachers' cottage and is nearly identical in design to Charlotte Hawkins Brown's home, built 20 years earlier.

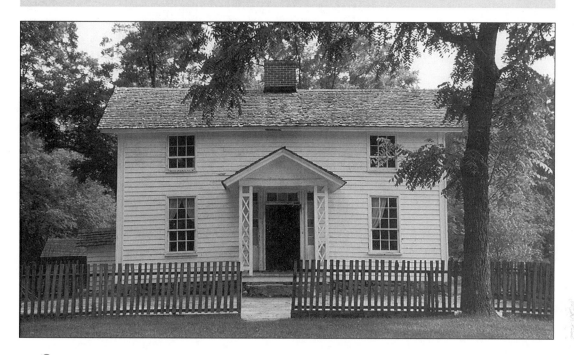

One of the major on-ramps to Tobacco Road is the Duke Homestead, a modest-looking farm that was the beginning of what became the largest tobacco company in the world.

Although "weed" was always an important product for North Carolina, the state was well behind Virginia in production of tobacco until after the Civil War. At that time, smoking preferences started to favor a mild-flavored type of tobacco, called "bright leaf" because of its golden color when cured. Bright leaf was grown in a relatively small area along the border of North Carolina and Virginia. The means of curing tobacco to produce this yellow-colored leaf came by accident on the Caswell County farm of Captain Abisha Slade in 1839, but once discovered, it became the standard.

The Civil War helped to popularize the tobacco grown in this region, as soldiers on both sides were introduced to the product. One story relates how, during the negotiations between Generals Sherman and Johnston, soldiers who were gathered at Durham Station visited the tobacco factory of John Green. They helped themselves to his tobacco without bothering to pay. Months later, however, letters came into the tiny hamlet from North and South, asking about the Durham tobacco and where it might be purchased. Thus, Green's product, Genuine Durham Smoking Tobacco—which had a bull pictured on its label—became the most popular brand of its day. Bull Durham,

as it soon came to be known, would at one time be the most recognized trademark in the world.

Washington Duke returned from the Civil War to his small farm outside Durham Station and a reunion with his four children. Born in 1820, Duke, the eighth of the 10 children of Taylor Duke, had been raised to work a farm. Around his 21st birthday, he had left home to take up tenant farming. He and his wife, Mary Clinton, had two sons, Sidney and Brodie, before her death in 1847. During that year, Duke acquired some farmland from his father-in-law, to which he was able to add some additional acreage. On that land, Duke built a simple two-story frame house with four rooms. It was ready by the time he remarried in December 1852, taking Artelia Roney of Alamance County as his wife. Together, they had three children—Mary, Benjamin, and James. In 1858, Duke's oldest son, Sidney, contracted typhoid fever. While attending her stepson, Artelia also came down with the fever. Both died, and Washington Duke was once again a widower.

The following year, on the eve of the Civil War, Duke planted his first tobacco crop. He soon decided that he was better suited to manufacturing than growing. Before he could take any action, however, the war came. Even though Washington Duke was a Unionist

Above: Washington Duke built this two-story, four-room home just prior to his second marriage.

and opposed to secession, he was drafted by the Confederacy in late 1863 or early 1864, as was his son Brodie. Leaving his other children in the care of the Roney family, Duke went off to war. He was captured and imprisoned in Richmond. At war's end, he was shipped to New Bern. From there, he walked the 135 miles back to his home. Although the war had interrupted his plans, it was only temporary. Back on his farm, and with the aid of his children, Duke began manufacturing smoking tobacco within the confines of a small log factory built within a stone's throw of his house.

The enterprising Dukes were successful in their endeavors, marketing their sacks of cured bright-leaf tobacco in eastern North Carolina. The bags bore tags on which appeared the handwritten motto "*Pro Bono Publico*," a Latin phrase meaning "for the public good." Current opinions of tobacco notwithstanding, the Dukes' product was well received. Within a few years, Washington Duke twice had to build larger processing factories on the homestead. By 1869, Brodie wanted his father to construct a factory in Durham, but Washington Duke decided to stay on the farm. He did, however, assist Brodie in opening a factory of his own in Durham, allowing his son to take full advantage of the rail transportation and warehousing facilities the town afforded. By 1874, the older Duke changed his mind and built a new factory in Durham, too, into which Brodie moved his business. Benjamin

and James, who went by the nickname "Buck," were made equal partners.

George W. Watts of Baltimore joined the Dukes as a partner in 1878, providing the firm—renamed W. Duke, Sons and Company—with working capital. Competition with W. T. Blackwell and Company, the successor to John Green, prompted the Dukes to begin the manufacture of cigarettes, which were just coming into vogue. The real success for the family business came in 1884, when the Dukes set up in their Durham factory a cigarette-rolling machine designed by James Albert Bonsack. Some factories employed workers to hand-roll cigarettes, but even the most skilled could produce only four or five cigarettes a minute. Bonsack's cigarette machine could produce 120,000 a day. Bonsack's cigarette roller had first been tried by a competitor of the Dukes, the Allen and Ginter Company of Richmond, but the Virginia factory had experienced frequent machinery breakdowns. The Dukes were able to correct those problems and in so doing established themselves as market leaders.

By that time, Washington Duke had spent many years involved mainly in marketing, while his sons were responsible for manufacturing. Buck Duke convinced four other large tobacco companies—Allen and Ginter, F. S. Kinney, Goodwin, and William S. Kimball—to merge with the Dukes. In 1890, the five competitors formed the American Tobacco Company. As a result

the school changed its name to honor its benefactors, and Duke University was thus born. The Dukes also used their earnings from tobacco to diversify into textiles and hydroelectric power.

Site History

After the Duke family moved to Durham in 1874, the homestead changed hands several times. Different tenants worked the farm. Over the years, the buildings fell into disrepair. In 1931, Mrs. Mary Duke Biddle and other family members worked with Duke University in purchasing the old homestead and most of the farm. The university soon restored the house to its original appearance and supplied it with period furnishings. In the early 1970s, the cooperative efforts of the university, the Durham Chamber of Commerce, the Department of Archives and History, and the tobacco industry resulted in the transfer of the property to the state as a historic site and the establishment of the Tobacco Museum. Federal funds allowed for the restoration of the Dukes' third factory. The visitor center was completed in 1977.

Things to See and Do

The visitor center at the Duke Homestead houses the Tobacco Museum, which recounts the history of tobacco from its earliest use by Native Americans to the present. Exhibits explain growing and harvesting procedures, curing techniques, manufacturing methods, and marketing strategies. The video *Carolina Bright* discusses what makes bright leaf different from other tobacco and how the curing processes practiced today are the outgrowth of a fortunate accident.

The homestead tour, which takes about an hour, gives visitors a good understanding of the steps required to move tobacco from the farm to the consumer at the time the Dukes started manufacturing in the late 1860s and early 1870s. The tour includes the pack house, the smokehouse, the curing barn, and the Dukes' third factory. It concludes at the Dukes' farmhouse, where the guides' presentation focuses on the family and what life was like on a North Carolina farm such as this one during the 1870s.

of the merger, the company had greater control over the growing, purchasing, warehousing, manufacturing, marketing, and distribution of its products. In 1911, just prior to its breakup as a result of the Sherman Antitrust Act, the American Tobacco Company controlled nearly 90 percent of the industry. When the "tobacco trust" was broken, four companies were created: the new American Tobacco Company, Liggett and Myers, P. Lorillard, and R. J. Reynolds, all of which operated in North Carolina.

The Dukes had become wealthy beyond their wildest expectations. To their credit, they were extremely philanthropic. Trinity College received huge endowments from Washington Duke and his sons. Years later,

Address and Location

Duke Homestead
2828 Duke Homestead Road
Durham, N.C. 27705
919-477-5498/919-479-7092 (fax)
www.ah.dcr.state.nc.us/sections/hs/duke/duke.htm

The homestead is in Durham about one mile off Interstate 85.

Opposite page, top left: After curing, tobacco was graded in this pack house. Top right: One of the few reconstructed buildings on the site is this replica of the Dukes' original factory, which was built around 1866. Bottom left: Within a few short years, Washington Duke's business outgrew a second building, necessitating the construction of this third factory. Bottom right: Young visitors try their hand at beating cured leaves into shredded tobacco. This page: The parlor window offers a view of the pack house and the third factory.

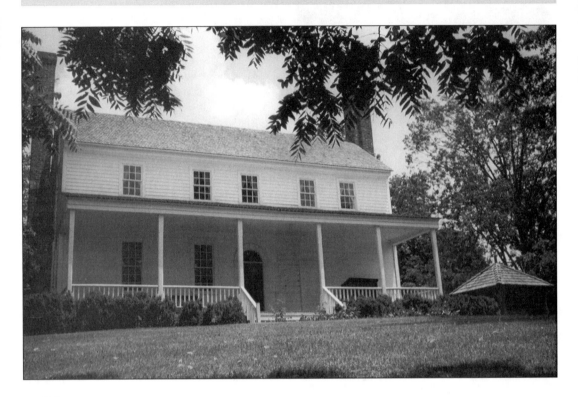

*T*he American Revolution was truly a civil war, as evidenced by events at the Philip Alston House in the summer of 1781.

North Carolinians were bitterly divided on the issue of independence from Great Britain. When the war finally erupted, a man all too often found himself fighting his neighbor. Harsh as the conflict may have been in the early years, when it roared into the Carolinas in 1780, the feuding between Whigs and Tories intensified. Patriots and Loyalists alike were accused of committing horrible atrocities against each other.

Two of the Piedmont's more notable adversaries were Philip Alston and David Fanning. Alston was a county clerk, a colonel of the local militia, and by most accounts both unscrupulous and vengeful. His Tory counterpart, Colonel Fanning, was a capable fighter whose guerrilla tactics were a thorn in the Patriots' side for more than a year. In the summer of 1781, Fanning's Tories were leading a group of Whig prisoners to Wilmington for confinement. Colonel Alston was in hot pursuit, hoping to catch Fanning and force the release of the prisoners. Fanning's men had too much of a lead, however, and Alston caught only one member of his band, Kenneth Black, who was returning home by himself with Fanning's lame horse. In-

tentionally or otherwise, the Patriots administered Black a fatal beating. Fanning, hearing that Alston was responsible for the killing, straightaway sought revenge.

There is some uncertainty regarding the exact date, but it was probably on Sunday, July 29, that Fanning and his men surrounded the Philip Alston House, trapping not only the colonel and his family but also about two dozen of Alston's militia. When a British officer in the company of Fanning, embarrassed or impatient with the duck-and-cover assault on the house, tried to lead a charge, he was shot dead. The direct approach having proved fatal, Fanning's men remained well covered. The two sides fired shots back and forth for hours, neither gaining an advantage. Inside the house, Mrs. Alston may have protected her children from the bullets ripping into the walls by having them stand inside a brick chimney.

As the day wore on, Fanning, fearful that Alston might receive help, tried another approach. Using a cart filled with hay as cover, his men pushed the wagon to the side of the house, the intent being to set the straw on fire and burn Alston's house down around him. Realizing their danger, the Patriots frantically debated how they might surrender with-

out being shot down in the process. Mrs. Alston, confident that no one would fire upon a woman, took matters into her own hands. Waving a white flag, she bravely stepped into the yard to meet with Fanning. She told him that the men inside the house would lay down their arms if Fanning agreed not to harm them or the house. Admiring the lady's temerity, Fanning agreed. He let the Whigs go in peace, upon the promise that they would not again take up arms in support of the Patriot cause.

Within a month of his attack on the Philip Alston House, the audacious Colonel Fanning succeeded in capturing North Carolina governor Thomas Burke, a number of officers, and about 70 militiamen in Hillsborough. Burke and his fellow prisoners were taken to Wilmington; the governor was eventually transported to Charleston. After Lord Cornwallis marched his troops to Virginia, Fanning continued harassing Whigs in the Carolinas for a year. He left when the British evacuated Charleston in 1782.

After hostilities ended, Alston was elected county clerk for a single term. When a political opponent, George Glascock, was murdered in 1787, Alston was implicated in the crime but never charged. He fled to Georgia in 1790, where, the following year, he was fatally shot while sleeping.

In 1798, the House in the Horseshoe was purchased by Benjamin Williams. An active supporter of the move for independence, Williams had been a successful officer during the war and had served in both state and national government in the years following. He held three consecutive one-year terms

as governor from 1799 to 1802 and served a one-year term again in 1807-8. Williams renamed Alston's former home Retreat and undertook the raising of cotton, which, due to the recent invention of the cotton gin, proved to be a hugely profitable venture. Under his management, the plantation grew and prospered.

Site History

The House in the Horseshoe, so called because of its location atop a hill in a bend of the Deep River, was built by Philip Alston in 1772. It was one of the first big houses along North Carolina's frontier. Alston sold the property in 1790. From 1798 until his death in 1814, the house was owned by Benjamin Williams. His son inherited the property in 1818. Ownership of the house and farm changed hands numerous times over the next century until the house, outbuildings, and four acres of land were purchased by the Moore County Historical Association for $5,000 in 1954. The following year, the state reimbursed the organization and assumed responsibility for the site, though it allowed the local organization to operate the property as a house museum. It opened to the public in 1957.

Governor Williams was buried a few miles away. In 1970, the state paid to have the vaults of the gover-

Opposite page: Built in 1772 by Philip Alston, the house gets its nickname from its location about a half-mile from a horseshoe bend in the Deep River. Below: To the left of the house are the gardens, corncrib, and loom house.

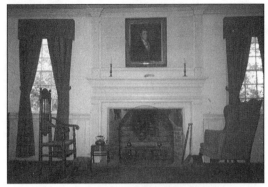

nor and his family moved to the homesite. Judging that the state would be better able to maintain the site, the Moore County Historical Association allowed its lease to expire in 1972. The property was designated a state historic site that same year.

Things to See and Do

The House in the Horseshoe is one of the few state historic sites in need of a permanent visitor center. At present, a small wooden structure serves in that capacity. No exhibits are on display, nor is there any audiovisual program. As at all sites, visitors are welcome to walk the grounds at their leisure. Guided tours of the house are usually given at the convenience of guests. Costumed tours and hands-on activities are offered to groups that schedule in advance.

In the downstairs dining room, docents detail the events that took place during the summer of 1781, directing attention to the brick fireplace where tradition holds that Mrs. Alston huddled her children to protect them from the gunfire. Opposite the central passageway, visitors are shown the parlor, where a portrait of Governor Williams hangs over the mantel. The two upstairs bedrooms display furniture of the period, allowing guides to talk about certain aspects

of life on the colonial frontier.

On their own, visitors can view the loom house, corncrib, and well. The graves of Governor Williams and his family are also nearby. Near the entrance to the site is a plaque commemorating the battle fought here. The marker was placed on the grounds in 1928 by the Daughters of the American Revolution.

Address and Location

House in the Horseshoe
324 Alston House Road
Sanford, N.C. 27330
910-947-2051/910-947-2051 (fax)
www.ah.dcr.state.nc.us/sections/hs/horsesho/horsesho.htm

The House in the Horseshoe is in Moore County about 10 miles north of Carthage on S.R.1621.

Top left: The dining-room fireplace may have offered protection for Colonel Alston's children during the skirmish. Top right: The portrait of Governor Benjamin Williams is the focal point of the parlor. Bottom left: A visitor tries her hand at the loom during one of the site's "living history" days. Bottom right: Bullet holes still scar the walls of the home.

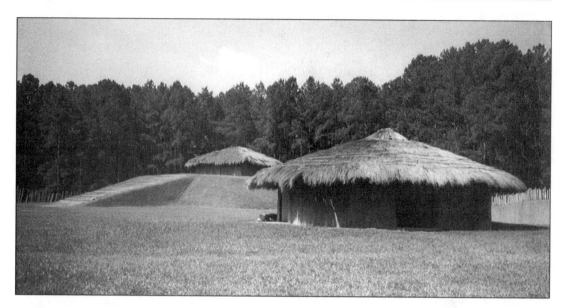

The first inhabitants of North Carolina were the Paleo-Indians, nomadic hunters who migrated to this area of North America as early as 10,000 B.C. Over thousands of years, during what is termed the Archaic period, these wanderers gave way to people who settled in particular regions. With the development of agriculture around 1000 B.C., a cultural change ensued, allowing hunters to give up their roaming lifestyle and begin establishing permanent homes. Families started settling into village groups. The advantages of living near creeks and streams gave birth to a mode of living referred to as the Woodland culture. The Woodland people flourished in the centuries that followed, learning to cultivate such plants as sunflowers, squash, and bottle gourds. By the end of the Woodland period, corn and beans were added to the diet. Farming was usually done by the women, while the men continued to hunt such game as deer, rabbits, raccoons, and opossums. Fish supplemented their diet. With permanent settlements came the advent of pottery making, the products of which were used for cooking, storing food, and holding water. The bow and arrow were also developed, replacing the spear as the primary tool for hunting game. By the 12th century A.D., various regions across the state were peopled by a multitude of Woodland tribes.

Concurrently, another culture flourished in the interior of the southeastern United States. This tradition, referred to as the South Appalachian Mississippian culture, was even more dependent upon farming than

was the Woodland culture. In fact, agriculture was the focal point of its religion. By 1200 A.D., the influence of the South Appalachian Mississippian culture reached the Piedmont of North Carolina and replaced that of the Woodland peoples living in the Pee Dee River Valley. Town Creek Indian Mound is a remnant of the ceremonial center of this South Appalachian Mississippian tradition—termed the Pee Dee culture, which existed here for only a comparatively brief time— rather than of the Woodland culture, which existed before and after.

Town Creek Indian Mound was the hub for religious, social, and political activities of the Pee Dee Indians who lived in small villages nearby. It was situated on a bluff near the junction of Town Creek and the Little River.

The protective stockade, built of sharpened logs bound together with cane and mortised with clay and straw, paralleled the riverbank for a distance before arching out in a large half-circle. In total, the stockade encompassed an area about 350 feet long and 350 feet wide. Two watchtower entrances on opposite sides provided guarded access to the compound. Only priests were allowed to live within the confines of the stockade, in a small hut referred to as the Minor Temple, located on the side nearest the river. Opposite the priests' residence, and dominating the compound, was

Above: A burial hut and the Major Temple are two of the three reconstructed buildings within the stockade.

the Major Temple. Archaeological studies have revealed that the first ceremonial temple was a simple earthen lodge. When this collapsed, the Indians covered it with a mound of earth, which formed the foundation for a second temple, this one rectangular in shape. When this structure was destroyed by fire, it, too, was covered by earth, providing an even higher mound upon which to build the third and final temple. Between the Major and Minor Temples was the Square Ground, at each corner of which were sheds or shelters decorated with the symbols of the clans that occupied them. Here, matters of religion and politics were discussed. Seating was determined by the status of the warrior or elder within his village. Adjacent to the Square Ground was a tall post used as a sort of goal for a variety of athletic contests. Games were played pitting warriors from the different villages against each other. The skull of a bear affixed near the top of the post was an appropriate symbol for the extremely physical and dangerous nature of the games. Also within the stockade were the burial huts, laid out surrounding the Square Ground and the athletic field. Burial huts within the ceremonial center were reserved for the most important members of the villages.

In addition to being a burial place and the site for political and religious discussions and competitive events, the ceremonial center provided the tribes of the Pee Dee River Valley a place for religious celebrations, many of which lasted for days. The Creek Indians were sun worshipers. One of their chief festivals centered on the harvesting of their most important crop: corn. This celebration, called the Busk, came at the time of the first harvest, which marked the beginning of the new year and symbolized the time for renewal and regeneration. Within individual villages, something akin to spring cleaning took place—houses were swept clean, old clothing was exchanged for fresh garments, used pots were broken and replaced with new, all to symbolize the renewal of life.

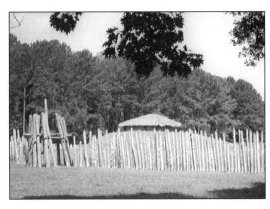

Above: The tall goalpost marks the center's athletic field. Right: The stockade and watchtower on the south side of the compound were left unfinished to give visitors a better understanding of their construction.

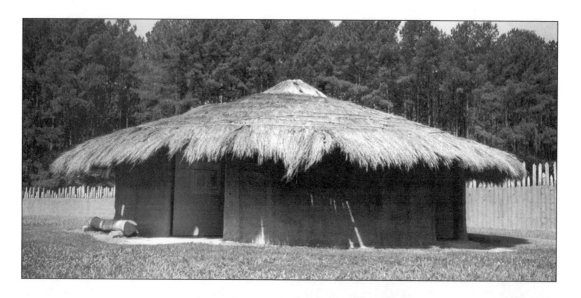

Site History

It is appropriate that, of all the properties maintained by the state as historic sites, the one that memorializes North Carolina's "first people of the Piedmont" was also the first to be designated such a site.

With a few notable exceptions, historic sites across

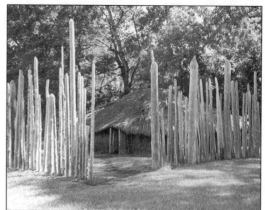

Top: Inside the mortuary is a diorama depicting the burial of a young girl of the Deer Clan. Left: The interior of the Major Temple shows the central fire, the altar, and various animal paintings. Middle right: The Minor Temple, home of the priests, is separated from the rest of the compound by a stockade. Bottom right: Portions of the Minor Temple were left incomplete to show details of construction.

the nation received scant attention until the late 1940s. Preservation of Town Creek Indian Mound, however, began as early as 1936, thanks to the foresight of property owner L. D. Frutchey. The site was already familiar to souvenir hunters and amateur archaeologists, who combed the grounds for bones and artifacts. Frutchey permitted the Archaeological Society of North Carolina to do some preliminary investigation and in 1937 donated about an acre of land to the state for the express purpose of continuing scientific exploration and establishing a state park. The park bore Frutchey's name for several years, until it became known as Town Creek in the early 1940s.

In 1955, the site was transferred from the State Parks Division of the Department of Conservation and Development to the Department of Archives and History. By that time, the state had purchased an additional 52 acres and a stockade had been reconstructed, but no other buildings had been rebuilt. During 1961 and 1962, a visitor center was completed. After much research, facsimiles of the Major Temple, the Minor Temple, and a burial hut were also completed.

Things to See and Do

The visitor center has exhibits on ceremonial activities, burial traditions, and pottery. Photographs document the site's excavation and the reconstruction of the stockade, the temples, and the burial hut. A 15-minute slide program gives a glimpse of the Woodland and Pee Dee Indian cultures of more than six

centuries ago; it also provides background on the archaeological research that went into preserving the site and that continues to this day.

A short trail behind the center leads to the reconstructed stockade. Passing through the tower entrance on the north side, visitors can go on a self-guided tour of the Major Temple, which stands on the same mound as the original, and a representative burial house. Inside the mortuary hut, a diorama depicts the burial of a young child of the Deer Clan; a brief audiotape explains details of the ceremony. The Minor Temple, home of the priests, has also been reconstructed. An opening in the south wall of the stockade allows visitors to follow a nature trial that parallels the creek that gave the site its name.

Address and Location

Town Creek Indian Mound
509 Town Creek Mound Road
Mount Gilead, N.C. 27306
910-439-6802/910-439-6441 (fax)
www.ah.dcr.state.nc.us/sections/hs/town/town.htm

Town Creek Indian Mound is located in Montgomery County just east of Mount Gilead. It is south off N.C. 731 and north off N.C. 73.

Above: The museum includes exhibits on archaeology and Indian culture.

West

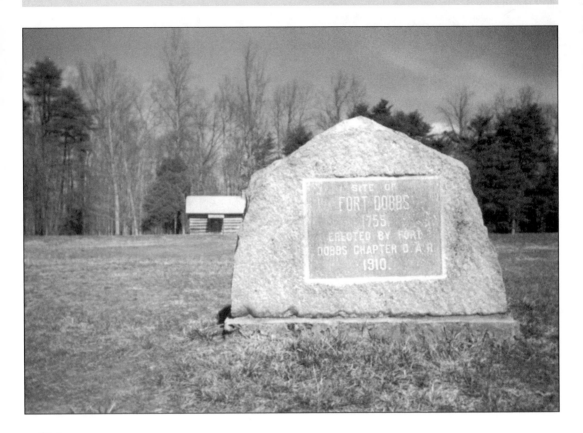

What little remains at Fort Dobbs is all that survives in North Carolina from the French and Indian War.

The site of the fort was chosen by Governor Arthur Dobbs and Captain Hugh Waddell in June 1755. Dobbs was visiting the province's back country, and Waddell was in command of his advance party. The captain, born in Ireland, had settled in North Carolina in 1754 after serving as a lieutenant in Virginia. Dobbs was in his second year as Royal governor of the colony. Like many of the settlers he visited on his western journey, he was of Scots-Irish descent.

Even though relations between settlers and Indians along North Carolina's frontier were quiet, conditions elsewhere led the governor to propose that a fort be built at the site chosen by him and Waddell. In 1756, the assembly appropriated £4,000 to pay for the construction of the fort, which was to measure 40 feet in width, 53 feet in length, and 24 feet in height. Within a matter of months, the log fort was erected and garrisoned. From 1756 to 1762, militiamen manned it from time to time.

Gradually, tension mounted between settlers and Indians. In October 1759, the Creek and Cherokee Indians declared war against the English. Settlers along the Yadkin and Catawba Rivers were justifiably alarmed. Some farmers fortified their homes for protection; elsewhere, neighboring families erected "stronghouses" for their mutual defense.

On the evening of February 27, 1760, a band of 60 to 70 Cherokees attacked Fort Dobbs. The defenders, led by the newly promoted Colonel Waddell, successfully beat off the attack, losing only one settler. Ten Indians died in the attack. About the same time, just a little distance to the east, the Moravian settlement at Bethabara was threatened, but since the colonists there were apparently in readiness, the attack never materialized. In June 1760, the assembly voted to raise a force of 300 men. By the winter of 1760, however, the danger seemed to have passed from North Carolina's frontier.

The fort may have still been standing at the outbreak of the Revolutionary War and may have provided protection against the Cherokee uprising in 1776. At least two children may have been born within its walls—one in 1756, the other in 1776. A map of the

province in 1775 showed the location of Fort Dobbs. At that date, no other nearby towns had formed. The exact fate of the fort is unknown, but it is likely that it either burned or was disassembled and its timbers used for other purposes.

Site History

Mary Colvert Talley spearheaded the earliest efforts to preserve the site, helping begin the Fort Dobbs Chapter of the Daughters of the American Revolution in 1909. That same year, John and Fannie Hatchett gave that organization a 1,000-square-foot lot that had been the location of the fort. In 1910, a granite marker was placed on the grounds by the D.A.R. The organization purchased 10 surrounding acres in 1915. For a half-century after that, various groups debated reconstructing the fort, but nothing resulted.

The state became interested in the site in the 1960s, but it was not until 1969 that the North Carolina General Assembly appropriated $15,000 for land acquisition and site development, provided the grant was matched by non-state funds. The Iredell County Historical Society mounted a successful campaign to do so.

Meanwhile, between 1967 and 1969, archaeological excavations determined the fort's exact location and some of its foundations. Although the authorization to construct Fort Dobbs in 1756 had stated what the dimensions of the stockade were to be, details were lacking, and a decision was therefore made not to place a reconstructed fort on the site. The property acquired by the Daughters of the American Revolution was given to the state in 1971. The state obtained additional land in 1973, bringing the total acreage to 33. Fort Dobbs was officially dedicated as a state historic site in 1976.

Things to See and Do

Still remaining on the grounds is a small wooden building constructed by the Daughters of the American Revolution, which serves as the temporary visitor center. It contains few exhibits, however, and there is no audiovisual program. The focal point of the site is the excavated foundation of the fort, but as noted above, no attempt has been made to reconstruct the building. The marker that the D.A.R. placed on the site in 1910 still stands near the foundation. One side of the stone has a bronze plaque commemorating Fort Dobbs, while the other side has a plaque indicating that the Boone Trail passed nearby. In a wooded area near the parking lot are a sizable picnic facility and a playground. Hiking and nature trails are also available for use.

Address and Location

Fort Dobbs
438 Fort Dobbs Road
Statesville, N.C. 28625
704-873-5866/704-873-5866 (fax)
www.ah.dcr.state.nc.us/sections/hs/dobbs/dobbs.htm

Fort Dobbs, two miles north of Statesville on S.R. 1930, is easily accessible from both Interstate 40 and U.S. 21.

Opposite page: This monument was placed on the grounds in 1910. This page: This view shows the excavated foundation of the fort.

\mathcal{H}orne Creek Living Historical Farm seeks to preserve North Carolina's deep agricultural roots. The bleat of a sheep, the smell of hay, and the sight of tomatoes ripening on a porch rail evoke in visitors a feeling of times past, when daily life was regulated by the rising and setting of the sun and the changing of the seasons.

The farm began as the homestead of the Hauser family more than a century and a half ago on 100 acres of land purchased by John Hauser. After marrying Elizabeth Poindexter in 1829, Hauser moved to his newly purchased farm the following year. Here, in the shadow of Pilot Mountain, he and Elizabeth raised five sons and two daughters in a log dwelling that no longer stands. With the help of three slaves, the Hausers raised a variety of crops and animals on the prosperous farm. Then three sons left to fight for the Confederacy; two died of diseases contracted during the war. Elizabeth died in 1864.

In time, the youngest son, Thomas, inherited and took over operation of the farm. He married Charlotte Kreegar in 1875 and soon began building a rambling frame house on a slope overlooking his father's home. Thomas completed his house in 1880. In its heyday, the Hauser farm, like many around the turn of the 20th century, depended heavily on crops long grown in the central Piedmont—corn, wheat, oats, rye, sorghum, and flax. The Hausers also raised hogs,

sheep, cattle, and fowl and tended a garden and an orchard. Fruit and tobacco were the main cash crops. Thomas had the help of his wife, 12 children, and several hired hands. He increased the farm's size to 450 acres by 1900.

Farmers like Thomas Hauser relied on simple, time-tested methods. Livestock provided power for working the fields. Crops were primarily grown for sustenance, though tobacco was rapidly becoming popular. Back then, farming was still manual labor. While machines were becoming important, they had not yet replaced strong backs. The house and the surrounding structures were built with the help of neighbors in day-long gatherings. More often than not, the only payment was a free meal and the promise of help in return.

Later, the farm passed into the hands of Hubert Hauser. Like his father, Hubert sired 12 children; once again, the land provided for their needs. The farm passed to a fourth generation of Hausers in 1960 but was leased to local farmers. In 1970, the land became part of Pilot Mountain State Park.

Site History

A longstanding desire to preserve North Carolina's agrarian heritage led to the formation in 1984 of a committee to explore the feasibility of creating an agricultural museum. Fortunately, the Hauser property, one

of the best-preserved examples of middle-class farming in North Carolina, was situated in an undeveloped part of Pilot Mountain State Park. Both the committee and the Division of Archives and History agreed on the site and together determined a strategy to develop the "living history" museum as a representative farm of the northwest Piedmont around 1900. The farm became a state historic site in October 1987, making it the most recent addition to the sites operated and maintained by the state.

Things to See and Do

A small modular unit serves as the temporary visitor center, There, staff members give visitors a brief overview of the site. Guests are then free to stroll the grounds. A walk of about a quarter-mile takes you to the farmhouse and the principal outbuildings. The house, open for inspection, has recently been abundantly furnished with pieces from the mid- to late 19th century. The house was home to three generations of Hausers.

The site is intended as a self-sufficient farm typical of the years 1900 to 1910. Visitors will find much to attract their interest. Staff members or volunteers will likely be engaged in the tasks that were common, everyday chores on the Hausers' farm. They grow corn and other staple crops and raise a variety of livestock: cows, chickens, sheep, and a mule. Cooking is done in the kitchen; a visit on a hot summer day helps one appreciate the hard work women put forth to feed their families.

The outbuildings include a smokehouse, a corncrib, a fruit house, a wellhouse, and a tobacco barn. The farm has an old orchard and garden, as well as a family cemetery. A trail behind the barn leads down to the creek that gives the site its name. A modestly strenuous walk from there along a wooded trail takes visitors on a roundabout path back to the center. Nearby, a new heirloom apple orchard will in time preserve more than 300 varieties of rare, old Southern apples.

Address and Location

Horne Creek Living Historical Farm
308 Horne Creek Farm Road
Pinnacle, N.C. 27043
336-325-2298/336-325-3150 (fax)
www.ah.dcr.state.nc.us/sections/hs/horne/horne.htm

The farm is located near Pilot Mountain State Park in rural Surry County, approximately six miles from the Pinnacle exit off U.S. 52.

Opposite page, top: The Hausers' home was built from the back forward. A two-room portion at the rear, from which the breezeway leads to the wellhouse, was constructed first, followed in later years by the two-story addition in front. Top right: This tobacco barn is typical of many seen even today along North Carolina's highways. Center right: The corncrib is large enough to store some farm equipment. Bottom right: The double-crib barn is often the scene of activity, as staff and volunteers tend the animals and complete daily chores.

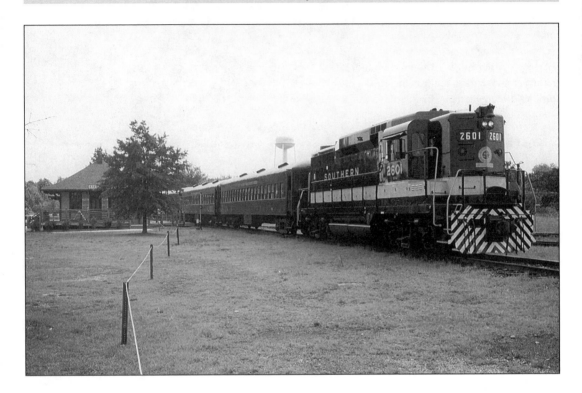

\mathcal{A}mong the most visited state historic sites is the North Carolina Transportation Museum at Spencer Shops.

In the mid-1890s, Southern Railway located its shops a few miles north of Salisbury, at roughly the midway point of its 600-mile line between Washington, D.C., and Atlanta, Georgia. Named in honor of Southern's first president, Samuel Spencer, the shops opened in 1896. The three original buildings were the 15-stall Roundhouse, the Machine Shop, and the Blacksmith Shop. Additional facilities were added over the next 20 years, including the massive Back Shop (1905), the Master Mechanic's Office (1911), the Turntable (1924), and an enlarged, 37-stall Roundhouse (1924), built on the site of the original. At its peak in the 1940s, Spencer Shops included 14 buildings and countless miles of track covering 127,000 square feet.

As the shops grew, so did the town that rose up around them. Also named Spencer, the town had an unmistakable link to its chief employer. In the 1920s, Spencer's population was 2,500, of whom 2,000 were employed at the shops. Sons followed fathers into jobs at the repair yards. Spencer was truly a company town. During the boom years, the shops operated three shifts daily, seven days a week. Skilled craftsmen, mechan-

ics, engineers, and laborers inspected, repaired, refurbished, and rebuilt Southern Railway's great steam locomotives. Minor repair work was done in the Roundhouse, while major overhauls—usually completed in 30 days—were done in the Back Shop, a huge building that stretched the length of two football fields. The yards at Spencer also constituted the largest freight-transfer facility in the South.

Spencer Shops were specifically designed for the maintenance and repair of steam locomotives. When the first diesel engine came to the shops in 1941, few who saw its arrival realized that they were witnessing the beginning of the end of the facility. Ironically, the first diesel engine was hauled to the site by a steam locomotive. Although work at Spencer continued for nearly two decades, it was impractical to refit the shops to do repairs on diesels, and activity steadily decreased. Work was gradually phased out, and the shops were virtually closed by 1960. Southern Railway gave the property to the state in 1977 for the purpose of creating a museum.

Site History

The idea of establishing Spencer Shops as a historic site began in 1976. Supported by Rowan County leg-

islators, the project gained the backing of the North Carolina General Assembly, which named Spencer Shops a historic site in July 1977. In September of that year, Southern Railway donated just over three acres to the state. Though funds were limited, the site managers were nevertheless able to acquire a number of locomotives and other railway cars within the year. Southern Railway then added another 54 acres to the site. A $1.25 million appropriation by the general assembly in 1979 allowed the initial renovation of the Master Mechanic's Office and the Back Shop to begin.

Improvements continued during the 1980s as funding permitted. These included acquiring additional restored railway cars, repairing the Turntable, producing an audiovisual program, and moving the old Barber Junction station to the site. The improvement that most enhanced the site's appeal, however, was the train ride, added in 1987. This attraction helped to double visitation. In 1990, the Bumper to Bumper automobile exhibit opened in the restored Flue Shop; this exhibit displays a rotating selection of cars from the turn of the 20th century to more recent years. The year 1996 saw the completion of major new railroad exhibits in the restored Roundhouse.

Things to See and Do

The North Carolina Transportation Museum offers myriad activities, some of which require a modest fee. It will take guests several hours to fully appreciate the site.

For a small fee, visitors can enjoy the 25-minute train ride, which leaves the Barber Junction station at prescribed times throughout the day; the ride is offered daily from April through August and weekends only from September through March. It takes visitors from the station to the Roundhouse and back; staff guides discuss items of interest about the shops along the way. A free shuttle also runs between the station and the Roundhouse. At the Roundhouse, guests can hop a five-minute "ride" on the Turntable or take part in hour-long talks on various railroad-related topics.

Two audiovisual programs are offered at the site. One is the 13-minute *History of Transportation* slide show, which guests may view at their convenience in the confines of an old refrigerated boxcar! The other is a 15-minute close-captioned video that reviews the genesis of railroading in North Carolina, focusing particularly on the history of Spencer Shops and the town. One segment of the video describes the tragic wreck of "Old 97" in 1903. Viewers also learn the fate of Samuel Spencer, who ironically met his demise in a train wreck in 1906, the result of a rear-end collision between two southbound trains near Lawyers, Virginia.

In the Master Mechanic's Office is an exhibit entitled Wagons, Wheels, and Wings, which covers the progress of transportation in North Carolina from Indian canoes to airplanes. The building also houses a sizable gift shop that offers a wide assortment of railroad memorabilia.

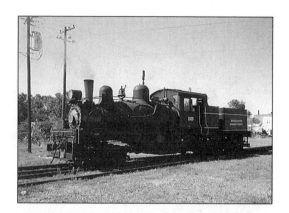

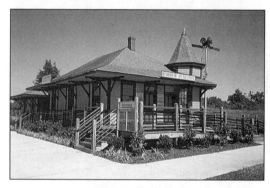

Opposite page: Different engines are used for the site's most popular attraction, the 25-minute train ride that takes visitors around the 57-acre rail yard. This page, top: Engine 1925 once worked the Graham County Railroad. Center: The quaint Barber Junction station is reminiscent of bygone days when rail transportation was king. Bottom: The massive Back Shop has been stabilized and given a new roof, but much time and money will be required to complete its restoration.

The Flue Shop is home to the Bumper to Bumper exhibit, where cars from 1900 to 1980 are on display. While the vehicles available for viewing are limited in number, they are imaginatively displayed against backdrops of barns, garages, and street scenes, which greatly enhance their appeal. The wood-block floor, the gas pumps, and the antique road signs add to the ambiance and set this exhibit apart from others of its type.

Of course, the locomotives, passenger cars, and cabooses on display in the Roundhouse are the main attraction. Each has been refurbished to a "like new" appearance. Viewing platforms allow visitors to see the interiors of selected cars and engines. Also in the Roundhouse is an exhibit area that includes a replica of the 1836 engine Raleigh, the first locomotive used by the Raleigh and Gaston Railroad, and a detailed, N-scale model of Spencer Shops around 1940.

Address and Location

North Carolina Transportation Museum
P.O. Box 165
Spencer, N.C. 28159
704-636-2889/704-639-1881 (fax)
www.ah.dcr.state.nc.us/sections/hs/spencer/
spencer.htm

The North Carolina Transportation Museum parallels the main street in Spencer, which is U.S. 70/U.S. 52. It is easily accessible from Interstate 85.

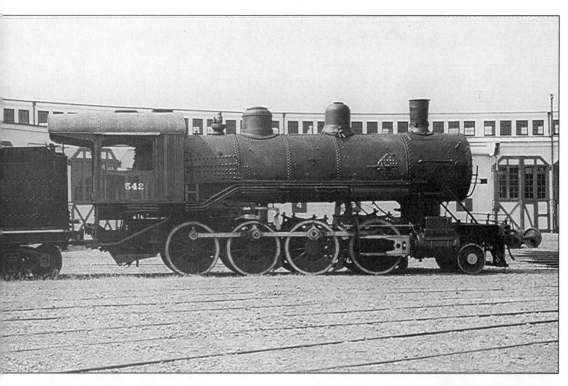

Opposite page, top: On display in the Roundhouse Museum is this full-size replica of the Raleigh locomotive, built in England in 1836 and used by the Raleigh and Gaston Railroad for more than three decades. Opposite page, bottom: Although the site was initially referred to as Spencer Shops, the name was changed to the North Carolina Transportation Museum in the mid-1990s, to reflect the addition of exhibits covering other modes of transportation. This page, top: For six decades, steam engines such as this one were serviced at the Roundhouse and its predecessor. Center left: Two cars on display in the Bumper to Bumper exhibit are the 1913 Ford Model T Depot Hack and the 1901 White Steam Stanhope. Center right: This 1930 Ford Model AA truck seems ready for a day's work. Bottom left: Among the cars on display is this 1959 Edsel.

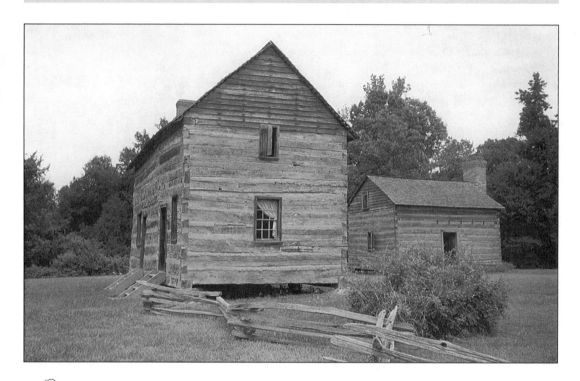

One of many impressive statues on the State Capitol grounds is that honoring the three United States presidents North Carolina gave the nation: Andrew Jackson, James K. Polk, and Andrew Johnson. A question exists as to whether Jackson was actually born in North or South Carolina; both states claim him as a native son. The small frame house in which Johnson was born still exists in Raleigh but was moved from its original site years ago and now stands in the capital city's Mordecai Park. Only the boyhood home of Polk, located in Pineville, is preserved as a state historic site.

Our country's 11th president was born in rural Mecklenburg County on November 2, 1795, the first of 10 children of Samuel and Jane Knox Polk. Although the Polks were a successful middle-class farming family, they moved to Tennessee when James was about 11 years old in search of more land and greater prosperity. Throughout his youth, Polk was frail and

Above: The main house is an example of a typical farmhouse in the North Carolina Piedmont around 1800. Opposite page: Approximately 400 citizens attended the unveiling of the Daughters of the American Revolution monument to President Polk on September 26, 1904. The stone pyramid was moved to its present location when work began on the reconstructed home.

sickly—so much so that his father decided to have him learn to read and write at home, rather than at a formal school. When James was 16, it was finally diagnosed that his poor health was the result of gallstones. Following a successful operation, he quickly gained strength and stamina. At age 17, he entered an academy that prepared him for enrollment as a sophomore at the University of North Carolina. In 1818, Polk graduated first in his class.

Polk was studying law in Nashville, Tennessee, when he was introduced to Andrew Jackson, a man who would greatly influence his political ideology. It was also in Nashville that Polk became reacquainted with Sarah Childress, the sister of a former schoolmate. Sarah stoked James's political ambitions and encouraged him to enter the race for the Tennessee legislature in 1823. His election was but the first step on what proved to be a lifelong career in politics. In 1825, Polk was elected to the United States House of Representatives, where he served for 14 years, including a term as Speaker of the House. He then won the Tennessee governorship in 1839.

Polk, a Jacksonian Democrat, hoped to be his party's nominee for vice president in 1840. It was not to be. The following year, he failed to win reelection as governor of Tennessee. He lost the gubernatorial

race again in 1843. Polk therefore seemed an unlikely candidate to receive the Democratic Party's nomination for president in 1844. Former president Martin Van Buren was the early favorite, but when the Democrats still had not chosen a candidate by their seventh ballot, Polk suddenly became a viable compromise for the disparate wings of the party. He won the nomination on the ninth ballot. Polk then challenged the Whig Party's Henry Clay, a well-known senator who had earned the nickname "the Great Compromiser." It was the Democrats' compromise candidate, however, who won the presidency, by an electoral vote of 170 to 105. The popular vote was much closer: 1,339,494 to 1,300,004. Polk's victory made him the nation's first "dark horse" president.

"Fifty-four forty or fight" was one of Polk's campaign slogans, but as president, he successfully—and peacefully—negotiated with Great Britain the northern boundary for the Oregon Territory, setting it at the 49th parallel. Polk's platform also endorsed the admission of Texas as the 27th state, which was accomplished shortly after he took office. Polk sent troops to patrol the disputed border territory between Texas and Mexico, an action that all but ensured that hostilities with Mexico would follow. Opponents dubbed the two-year conflict "Mr. Polk's War," but the treaty that ended the war in 1848 ceded to the United States considerable land, including the New Mexico Territory and California. This earned for Polk the distinction of being the most expansionist of all presidents. For the first time, the United States and its territories stretched from the Atlantic to the Pacific, helping fulfill what many of Polk's contemporaries considered America's "Manifest Destiny." Iowa and Wisconsin joined the Union during Polk's term, and the territories of Oregon and Minnesota were formed. President Polk also fulfilled two other major campaign promises: reducing the tariff and reestablishing an independent treasury. The United States Naval Academy was established during his administration.

Polk intended from the beginning to be a one-term president. He and Sarah left Washington in March 1849 to return to their home in Nashville. Three months later, Polk was stricken with cholera and died. Many felt that he had given too much of himself while in office and had worked himself to exhaustion, making him more susceptible to an illness that he otherwise might have been able to overcome. He was buried on the grounds of the Tennessee State Capitol.

Site History

The first efforts to memorialize the birthplace of President James K. Polk were undertaken by the Mecklenburg Chapter of the Daughters of the American Revolution. In 1904, a rough stone monument was dedicated near the foundation of what was thought to

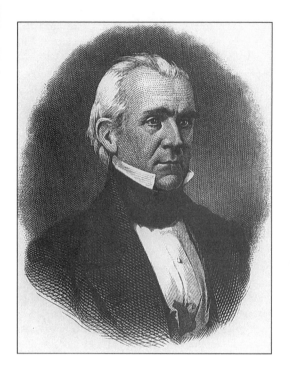

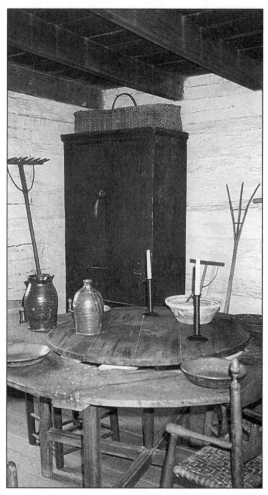

be the farmhouse where Polk was born. The land was still privately owned, however, and in the early 1950s, it became overgrown. James A. Stenhouse, a Charlotte architect and historian, is credited with spearheading a drive to preserve the site. Because of anticipated suburban development in the Pineville area, land values escalated dramatically. Several years elapsed before the state was finally able to purchase 21 acres. The landmark became a state historic site in 1964.

Research in that year indicated that U.S. 521 probably passed over the actual location of the Polks' farmhouse, so an area 200 yards northeast was chosen for the site of the reconstructed farm. Two area log houses, both dating to the early 1800s, were dismantled and reassembled to create the main house. The final appearance of the house was based in part on speculation and in part on a written description in a letter by former governor David L. Swain in 1851; Swain, a student of history, had visited the home in 1849. A detached kitchen and a barn were also moved to the site from neighboring communities. Construction of the visitor center began in November 1967 and was completed the following spring. Appropriately, First Lady Claudia "Lady Bird" Johnson dedicated the site on December 6, 1968.

Things to See and Do

Docents give visitors guided tours of the main house and the kitchen. The 1904 stone pyramid monument erected by the Daughters of the American Revolution

was moved from its original location and stands a short walk from the main house. The visitor center offers a 22-minute film that uses the 1844 presidential campaign's oft-asked question—"Who Is Polk?"—as its theme. The museum attempts to answer that question by providing a look at the things that shaped Polk's outlook. Included are exhibits on farm life in the North Carolina Piedmont in the early 1800s; on the clash of agrarian society and the industrial revolution during the "Spirited Age"; on Polk's political career and the presidential campaign of 1844; and on the Mexican War. Of particular note among the many artifacts on display is the dress chapeau worn by General Santa Anna, a trophy of the Mexican War taken by the president's younger brother, Major William H. Polk.

Address and Location

James K. Polk Memorial
Box 475
Pineville, N.C. 28134
704-889-7145/704-889-3057 (fax)
www.ah.dcr.state.nc.us/sections/hs/polk/polk.htm

The James K. Polk Memorial is located on U.S. 521 approximately one mile south of Pineville.

Opposite page, top left: James K. Polk served one term as president, from 1845 to 1849 (photo courtesy of North Carolina Department of Cultural Resources). Bottom left: The kitchen features an unusual lazy Susan dining table. This page, top: The 200th anniversary of Polk's birth drew large crowds to the memorial. Bottom right: The largest room in the main house is the combined sitting room and bedroom. Bottom left: A vegetable garden and a barn are located near the kitchen.

For all the grandeur of George Vanderbilt's palatial home, it is doubtful that even Biltmore Estate could boast of a doorstop worth $3,600. Farmer John Reed's humble home could.

Reed has been described as "honest but unlearned," a German who came to the colonies as a Hessian soldier during the American Revolution. He deserted the British while in Savannah, Georgia, and escaped to what was then a part of eastern Mecklenburg County, North Carolina. A number of other Germans lived in the area, so John Reed settled in to make a new life for himself. In 1792, the same year that Cabarrus County was sectioned off from Mecklenburg, Reed received a land grant from the state for 70 acres along Little Meadow Creek. Reed was married and the father of five by that time.

It was on a spring day in 1799 that Reed's 12-year-old boy, Conrad, went bow-and-arrow fishing in the creek. In the company of a sister, Conrad happened upon an odd-colored rock that caught his fancy. With effort, he pulled the rock from the creek bed and toted it home. No one in the family could identify it.

Conrad's oddity was subsequently put to practical use, propping open the cabin door on hot summer days.

Three years later, curiosity got the best of John Reed as he was preparing to go to market in the distant town of Fayetteville. He took the rock with him and had it identified by a jeweler. Returning home in triumph, Reed told his excited family that the 17-pound rock was gold! Asked by the merchant to name his price, the shrewd German determined that $3.50 was just compensation; as that amount was the equivalent of a week's wages, it seemed a more-than-fair exchange for a doorstop. Reed used the money to purchase a calico dress for his wife, Sarah, and a sack of coffee beans. The jeweler, meanwhile, had the gold melted and formed into a bar, which he sold for $3,600, a tidy return on his investment.

While John Reed remained a farmer at heart for the rest of his days, he realized there was "gold in them thar hills." In 1803, after he and his family had searched the creek for more gold stones, Reed went into partnership with three local men—the Reverend James Love, Martin Phifer, Jr., and Reed's brother-in-law,

Frederick Kiser. Love, Phifer, and Kiser provided the slave labor and equipment, Reed provided the land, and the profits were divided equally among the four men. During the first year of partnership, a slave named Peter found a gold nugget weighing 28 pounds.

Initially, the men did what was called placer mining, digging dirt from random places along the creek bed and panning for gold nuggets. Later, "rockers" were introduced that allowed the men to sift more quickly through larger amounts of earth. In the two decades that followed, more mines were opened in surrounding counties. It was not until 1825, however, that placer mining finally gave way to underground mining in North Carolina. A Montgomery County farmer named Matthias Barringer found gold in veins of white quartz rock. Spurred by this discovery, prospectors located many gold veins in Mecklenburg, Cabarrus, and adjacent counties.

Digging tunnels required the investment of much capital, equipment, and manpower, as did the process of grinding the ore after it was dug, which changed the nature of mining in North Carolina in the decade that followed. Investors across the country bought stock in mining companies, lured by the prospect of handsome returns. Underground mining did not begin on the Reed property until 1831, but it quickly proved profitable. The volume of gold earned North Carolina the nickname "the Golden State." In 1835, Congress authorized a branch mint to be built in Charlotte. The facility was completed in December 1837. Before the Civil War shut down its operation, the Charlotte mint produced about $5 million in gold coins.

Underground mining at the Reed property led to problems in 1834, when a 13-pound nugget was discovered. How the nugget was to be divided among the partners caused strained family relationships and legal battles. For 10 years, the mine stood idle. A settlement was reached shortly before John Reed's death at age 88 in 1845. Operations at the mine continued at various intervals, under numerous owners, and with varying returns for another 70 years. The facility was finally shut down in 1912.

Site History

The Kelly family of Springfield, Ohio, bought the Reed property in 1895; although they were unable to profitably mine gold, the Kellys kept and used the tract

Opposite page: Visitors listen as a guide describes working conditions in the old Reed Gold Mine (photo courtesy of North Carolina Department of Cultural Resources). This page, above: Exhibits in the visitor center trace the development of the gold industry in North Carolina. Right: The kibble above the Morgan Shaft provided a means for lowering men and equipment into the mine and raising the ore.

as a retreat. In 1966, the United States Department of the Interior designated the mine a National Historic Landmark. At the close of the decade, the North Carolina Division of Archives and History began negotiations with the Kelly family. In 1971, the state purchased 753 acres at below market value and received as a donation the original 70 acres used for mining. The National Park Service put together a comprehensive plan for the site, and in 1973, the North Carolina General Assembly appropriated $650,000 for development. Over the next four years, 400 feet of underground tunnels were restored and stabilized, a visitor center was completed, footbridges and walking trails were added, and other amenities were finished. The site opened to the public in April 1977. The last major addition came in the early 1980s, when a stamp mill, still in operating condition, was claimed from an abandoned mining operation in Montgomery County and installed at the Reed site.

Things to See and Do

A visit to the Reed Gold Mine offers both education and adventure. Guests touring the museum will see exhibits illustrating the various types of mining done in the Carolinas, time lines showing gold production in the region, pieces of equipment used in the mining process, and even some of the gold coins minted locally. A 22-minute film tells the story of young Conrad Reed's amazing discovery and of the subsequent gold rush. A pleasant walk under shade trees takes visitors to the mine, where guided tours are offered hourly. On hot summer days especially, the blast of naturally cool air from the mine entrance is reason enough to take the tour, which offers a glimpse of mining operations as they existed over 100 years ago. While the mine tour is the "main event," the most enjoyable part of the visit may be the opportunity, for a modest fee, to pan for gold. The prospect of discovering a few flakes excites both young and old. Staff members are on hand to show amateur prospectors how to pan. Panning is not available during the off-season (October through April) or during inclement weather.

Address and Location

Reed Gold Mine
9621 Reed Mine Road
Stanfield, N.C. 28163
704-721-4653/704-721-4657 (fax)
www.ah.dcr.state.nc.us/sections/hs/reed/reed.htm

The site is approximately 12 miles southeast of Concord off S.R. 200 on Reed Mine Road, about midway between N.C. 49 and N.C. 24/N.C. 27.

Below: Visitors of all ages enjoy the prospect of striking it rich.

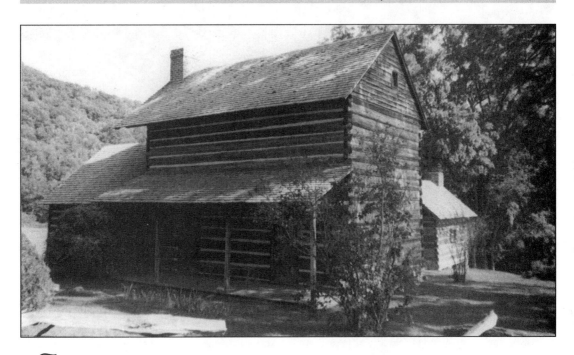

The Blue Ridge Mountains are the backdrop for the memorial to one of North Carolina's favorite sons, Zebulon Baird Vance.

Zeb Vance was of Scots-Irish descent, his grandfather David Vance having immigrated to North Carolina in the mid-1700s. An active revolutionary, David Vance saw action at Brandywine and Germantown, endured the hardships of Valley Forge, and fought in the Patriot victory at Kings Mountain. Sometime between 1785 and 1790, he moved from the Catawba River Valley in Burke County to what is now Buncombe County. In 1795, he bought land for a home along Reems Creek. Vance served three terms in the state legislature. In 1796, he was appointed one of three commissioners entrusted to settle the boundary line between North Carolina and Tennessee. He also served as clerk of court for the newly formed Buncombe County and was elected colonel of the militia.

Vance's son, also named David, inherited the farm upon his father's death in 1813. He, too, served his country in the military, as an officer in the War of 1812, rising to the rank of captain. In 1825, he married Mira Margaret Baird, daughter of Zebulon Baird, another Scottish pioneer who helped settle western North Carolina. A successful merchant, Zebulon Baird served four terms in the lower house of the general assembly and two terms in the state senate. When David and Mira's second son was born on May 13,

1830, he was named Zebulon Baird Vance in honor of his maternal grandfather.

Zeb's education came in rural, one-teacher schools until he was 12, when he was sent to Tennessee to attend Washington College. While there, he shared with a fellow student a vision he had of one day becoming the governor of North Carolina. During his second year at Washington College, his father died, and Zeb returned home. He attended Newton Academy, worked for a time as a hotel clerk, and in 1851 was accepted at the University of North Carolina in Chapel Hill. His expenses were paid by a loan extended by the university president, David L. Swain. After one year at the university, Vance passed the state law exam. He was admitted to the bar in 1852. Vance returned to the mountains of western North Carolina to begin his practice, which, thanks largely to his good humor and engaging personality, drew many clients. He married Harriette Espy on August 3, 1853. The couple would have five children over the course of a long marriage.

In 1854, Vance sought election on the Whig ticket as a representative of Buncombe County in the lower house of the general assembly. When, during a well-attended debate, his opponent criticized him for being

Above: The two-story Vance "birthplace" is a careful reconstruction built in 1960.

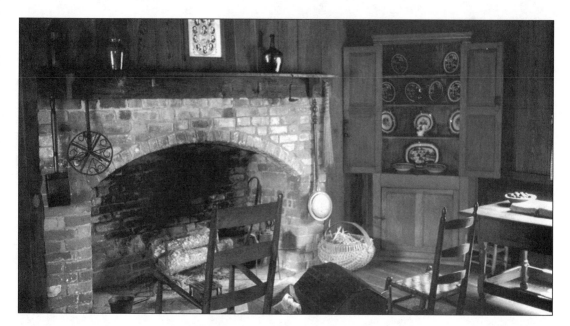

too young, Vance apologized for his shortcoming, explained that he had no say in the matter, and promised to do better the next time. His quick wit endeared Vance to voters and helped him win the election, launching him on a career of public service to both state and nation that would span more than four decades.

Although Vance lost his 1856 bid for the state senate, the young lawyer had an opportunity for public service again in 1858, when United States representative Thomas Clingman resigned his seat in the House to become one of North Carolina's senators. Vance won the election to fill the unexpired term, then successfully campaigned for reelection in 1860.

The years Zeb Vance served in the House of Representatives were difficult ones, the schism between North and South growing ever wider. A staunch Unionist, Vance did all he could to convince his fellow North Carolinians that the state should not secede. He was, in fact, traveling across his home state to voice his position to his constituents when news came of Lincoln's call for men from North Carolina to take up arms against the insurrection in South Carolina. As Vance himself later wrote, his arm was raised in defense of the Union when the news arrived, only to fall "slowly and sadly by the side of a Secessionist."

In many respects, Zebulon Vance mirrored his state. North Carolina opposed secession until after the siege of Fort Sumter and Lincoln's call to arms. Reluctantly, in May 1861, the Old North State became the 11th, and last, state to join the Confederacy. Once the decision was made, however, North Carolina was at the forefront in every regard. Some 125,000 men—

one-sixth the total number to serve in the Confederate army, and more than were sent from any other state—came from North Carolina. Its troops were "first at Bethel, farthest at Gettysburg and Chickamauga, last at Appomattox." So, too, did Vance, the reluctant secessionist, devote himself wholeheartedly to the cause once he declared himself for it. After signing on as a private in a Buncombe County militia unit, the Rough and Ready Guards, Vance was soon elected captain. This unit was assigned to the 14th North Carolina Infantry. The gregarious lawyer from Asheville was subsequently elected colonel of another regiment, the 26th. The 26th engaged in heavy fighting in the unsuccessful defense of New Bern in 1862, during which Vance was recognized as a skilled leader. In combat at Malvern Hill, the last of the Seven Days battles that saved Richmond from George McClellan's Federals, the 26th North Carolina again quit the field with honor, if not victory, their commander once more demonstrating courage and leadership.

The name Zebulon Vance was rapidly becoming known in his home state. Vance was nominated for governor. Gradually convinced by friends that he could better serve the Confederate cause as chief executive of North Carolina than as an officer on the front line, he accepted the honor. He chose to remain with his troops in the months leading up to the election, however, leaving the campaign stumping to his opponent, William Johnson, a railroad executive from Charlotte. Vance won the election by 34,000 votes.

Assuming office on September 8, 1862, Vance quickly undertook the difficult task of governing a state in turmoil. Much of eastern North Carolina was in

Federal control. Disaffection in western North Carolina and even in some of the Piedmont counties was growing. With men off to war, wives and children struggled to maintain their family farms. Basic necessities were in short supply on the home front. Through it all, Vance sought to keep order, doing everything possible to curb profiteering. He entreated the legislature to appropriate $190,000 for the purchase of an English side-wheel steamer. Renamed the *Ad-Vance* in the governor's honor, the sleek steamship became one of the most successful of all blockade runners. From May 1863 until her capture in September 1864, the *Ad-Vance* brought desperately needed supplies to the port of Wilmington. Vance's most notable accomplishment, however, was his ability to maintain civil law within the state. Before the end of the war, the governments of every Confederate state save one had imposed martial law. The sole exception was North Carolina, thanks largely to the tenacity and determination of Governor Vance.

In 1864, the "War Governor" visited Robert E. Lee's troops in Virginia. Since James Longstreet's division was currently assigned to the Army of Tennessee, North Carolinians comprised the majority of the Army of Northern Virginia. Ever the skillful, energetic orator, Vance helped renew the morale of the common soldier, impressing even the likes of Generals J. E. B. Stuart and Lee.

Back at home, Vance had to campaign for reelection, challenged this time by Raleigh newspaperman W. W. Holden, editor of the *Standard* and a supporter of Vance in the 1862 election. Witnessing Southern fortunes declining daily, Holden argued for North Carolina to secede from the Confederacy and sue for a separate peace with the North. Vance decried any such action, remaining loyal to the Confederacy he had once so ardently opposed joining. Despite their sufferings, North Carolinians wholeheartedly supported their governor, reelecting Vance by a four-to-one margin. (Holden later served as governor during the Reconstruction period.)

In April 1865, four days after Lee's surrender at Appomattox, General William T. Sherman's troops occupied Raleigh, the last Confederate capital to be captured. Governor Vance had fled the city the night before its occupation, returning to his home in Statesville and a short reunion with his family. Ironically, it was on May 13, his 35th birthday, that Vance was arrested by Federal troops. Although no charges were ever made against the governor, Vance was imprisoned in Washington, D.C., for two months, after which Secretary of War Edwin Stanton released him.

Vance soon renewed his legal career, practicing in Charlotte. Among his clients was Tom Dula, known to many Americans today because of the popular folk ballad "Tom Dooley." A former Confederate soldier, Dula was accused of the murder of his supposed sweetheart, Laura Foster. The trial received much attention both nationally and locally. Vance succeeded in having it moved from Wilkes County to Iredell County and in having Dula's trial separated from that of Ann Melton, a married woman with whom Dula had enjoyed a romantic tryst and who was charged with abetting Dula in the murder. In spite of Vance's best efforts, however, his client was found guilty in late fall 1866. In 1867, Vance was able to have the case tried again, but the verdict remained the same. Dula was sentenced to be hanged; the execution was carried out in Statesville on May 1, 1868.

In 1870, Vance was chosen by the state legislature to serve in the United States Senate, but that body, controlled by Radical Republicans, refused him his seat. In 1876, he was again elected to the office of governor. During that term, he worked diligently to improve the state's public-school system. It was also during his term that Federal troops were withdrawn

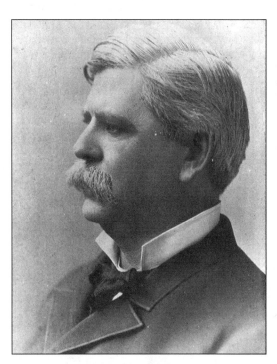

Opposite page: The main room of the home includes the original brick fireplace. This page: Zebulon Vance served his native state as a United States congressman, soldier, governor, and United States senator (photo courtesy of North Carolina Department of Cultural Resources).

from North Carolina. Following this stint as governor, Vance went to Washington as a member of the Senate in 1879. He was still serving in that capacity when he died on April 14, 1894.

Zebulon Vance is one of the state's most honored sons. A granite obelisk stands in his memory in the heart of Asheville, and a statue of the governor is among many others on the grounds of the State Capitol. The town of Zebulon and the county of Vance are named in his honor, and he is one of two North Carolinians honored with a life-size bronze likeness in the Statuary Hall of the United States Congress. The Zebulon B. Vance Birthplace is the most recent memorial to this Tar Heel statesman.

Site History

The original home built by Colonel David Vance was apparently dismantled and replaced by a new frame house sometime in the late 1800s. Although interest in restoring the property and creating a memorial to the late governor was evident as early as 1924, when the Asheville Chapter of the United Daughters of the Confederacy inquired into purchasing the land, nothing of consequence took place until 1955. In that year, the state purchased the house and two and a half acres of land from Claude and Ernest Wheeler. It was not until 1960, however, that a reconstruction of the farmhouse was begun. The exterior of this replica—which incorporated the brick chimney, the only external portion that remained of the original Vance home—was completed in December 1960. Interior work that included original paneling, flooring, a door, and rafters was finished shortly thereafter, as were a reconstructed smokehouse and a slave cabin. Furnishings dating to the period from 1800 to 1830 were purchased for the home, and the birthplace was dedicated as a memorial to the governor on May 13, 1961, the 131st anniversary of Vance's birth. A loom house was added in August 1961; two years later, a smokehouse and a corncrib were moved to the site from a farm in Yancey County. The purchase of additional land allowed construction to begin on a visitor center in January 1965; the center was completed that October. The physical appearance of the memorial has remained largely unchanged since that time.

The first Pioneer Living Day event, featuring demonstrations of daily household activities, was held at the birthplace in 1968, making it the oldest ongoing special program among all those offered by the state historic sites.

Things to See and Do

The visitor center includes a small exhibit area detailing different periods of Zebulon Vance's life and political career. A 15-minute slide show traces his life, focusing especially upon his early years in rural western North Carolina and his terms as governor during the war. Guided tours of the entire site, including all the outbuildings, range from 30 to 45 minutes.

The main house is a two-story structure. The rooms are well furnished with period pieces, though only a few of the items displayed were actually owned by the Vance family. The numerous outbuildings include a loom house, a toolshed, a corncrib, a smokehouse, a springhouse, and a slave cabin.

Address and Location

Zebulon B. Vance Birthplace
911 Reems Creek Road
Weaverville, N.C. 28787
828-645-6706 / 828-645-0936 (fax)
www.ah.dcr.state.nc.us/sections/hs/vance/vance.htm

The birthplace is on Reems Creek Road off U.S. 19 / U.S. 23 approximately 12 miles northeast of Asheville.

Left: This view from behind the visitor center shows the main house, the loom house, and the toolshed. Below: A representative slave house was reconstructed at the rear of the homesite.

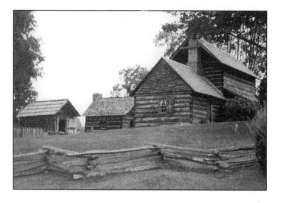

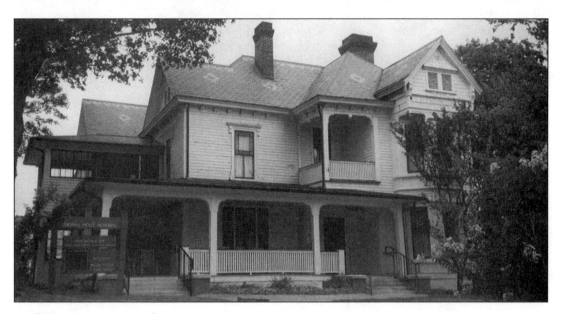

The address—48 Spruce Street, Asheville, North Carolina—is not readily identified by most people, yet the house that stands there is known to generations of readers via Thomas Wolfe's novel *Look Homeward, Angel*. In the book, the 29-room boardinghouse is called Dixieland; in real life, it is the Old Kentucky Home, where Wolfe spent much of his early life. It serves as the stage for much of the drama of his novels.

Thomas Wolfe's home life gave meaning to the term *dysfunctional family*. His father, William Oliver Wolfe, was a skilled stonecutter, a friendly, easygoing individual who enjoyed entertaining friends with his oratory. He was also prone to depression and drunkenness. Thomas's mother, Julia Elizabeth Wolfe, was an enterprising, industrious woman given to putting financial gain ahead of the needs of her husband and children. Their turbulent marriage left its mark on the Wolfe children. The experiences of his youth and early manhood gave Thomas the material for his novels.

The last of eight children, Thomas was born October 3, 1900, in Asheville. When he was six, Julia Wolfe went against her husband's wishes and purchased a house on Spruce Street to operate as a boardinghouse. W. O. Wolfe refused to move from the family home on Woodfin Street two blocks away; from that point on, the couple lived apart. Young Tom felt torn between his childhood home, where his father still lived, and his new environment, where strangers occupied every room. Particularly distasteful to the lad was his mother's insistence that he solicit boarders for the house by handing out calling cards at the Asheville train depot.

Thomas's father was well read and placed a high value on education. He arranged for his youngest son to attend a private school during his early teens. It was through the encouragement of the school's headmistress that Thomas's literary talents were first developed. At the age of 16, he entered the University of North Carolina. There, the tall, lean Wolfe distinguished himself both scholastically and socially. He also determined that he would become a playwright. While at the university, Wolfe suffered the loss of his brother Ben. Many years his senior, Ben was for Thomas a surrogate father, friend, confidant, and adviser. His brother never enjoyed especially good health, however, and an aimless lifestyle, a poor diet, and heavy drinking and smoking hastened the inevitable. Thomas blamed his brother's premature death on the contentious nature of the family.

After graduating from Chapel Hill, Wolfe was anxious to continue his education at Harvard. Although W. O. Wolfe disapproved, Julia supported her son in this endeavor. It was while studying at Harvard that Thomas was once again called home, this time to attend his father's deathbed. Wolfe returned to Harvard and began to write plays, but they were too lengthy and too introverted to be well received. After graduation,

Above: Extensive additions made by Julia Wolfe in 1916 brought the Old Kentucky Home to its present appearance.

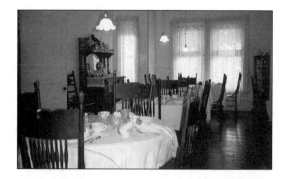

he embarked on a voyage to Europe. It was on this trip that he began to scribble notes of his days as a youth in Asheville.

It was also at this time that Wolfe became involved with an older woman, whom he looked upon as a mentor. With her encouragement, he took his now-voluminous collection of notes to a publisher. It seems possible that Wolfe would never have been recognized as a gifted writer had he not benefited from the services of two excellent editors, Maxwell E. Perkins and, later, Edward Aswell. The first, Perkins of Charles Scribner's Sons, understood Wolfe's talent but also found his manuscript to be overwritten and without focus. Working long and hard with the young writer, Perkins helped Wolfe establish Eugene Gant, the author's alter-ego, as the central character and limit the scope of the novel to that character's adolescence.

Published in 1929, *Look Homeward, Angel* was critically acclaimed everywhere but Asheville, where citizens were merely critical. Essentially autobiographical, the book contained characters so thinly veiled as to be readily identifiable; it also uncovered some skeletons. Not surprisingly, the book was banned from the Asheville library. In 1936, when author F. Scott Fitzgerald visited town and found no copy of *Look Homeward, Angel* in the library, he made a gift of several copies, thus ending the ban.

Flush with success, sustained by his book royalties, Wolfe traveled widely. His second book was *Of Time*

and the River, edited by Perkins over the course of a full year. Following its publication in 1935, Wolfe felt it necessary to change publishers, perhaps to demonstrate that he was not dependent upon Perkins. Before another novel saw print, however, Wolfe was taken ill while traveling the United States. The author was rushed to a hospital in Baltimore, where it was discovered that he was stricken with brain tuberculosis. Emergency surgery was unsuccessful. Thomas Wolfe died September 15, 1938, days shy of his 38th birthday. Three books published posthumously— *The Web and the Rock*, *You Can't Go Home Again*, and *The Hill Beyond*, all taken from a manuscript Wolfe intended to be one book—added to a literary canon that included numerous short stories, plays, essays, and reviews.

Site History

The house at 48 Spruce Street was constructed as a seven-room Queen Anne-style home in 1883. Additions made in 1889 doubled the size of the house, which was purchased by Julia Wolfe in 1906. A previous owner had called the place his "Old Kentucky Home," in honor of his native state. Mrs. Wolfe kept the name and began a successful boardinghouse for businessmen, travelers, and tourists enjoying a quiet respite in the mountain city. In 1916, Mrs. Wolfe made many improvements, including the addition of indoor plumbing and 11 more rooms, giving the house 29 rooms in all. She continued to live in the house until

her death in 1945, when it was passed on to her four surviving children.

In 1948, the heirs put the house on the market, hoping it would be purchased by an individual or group desiring to establish a memorial to their late brother. In response, the Thomas Wolfe Memorial Association was formed. Headed by leading Asheville citizens like the mayor and the editor of the city's newspaper, it succeeded in acquiring the house for $15,570. The home was opened as a memorial to Wolfe in 1949—thanks, ironically, to the efforts of the townspeople who had banned the author's first book! The city of Asheville assumed operation of the site in 1958.

The Department of Archives and History acquired the property from the city in 1974 and closed the house for needed restoration before reopening it in 1976. Although land adjacent to the boardinghouse was acquired in the early 1980s and funds for a visitor center were appropriated in 1988, complications prevented the center's completion until the mid-1990s.

In July 1998, the house was nearly lost due to a fire deliberately started by vandals. Early detection of the fire and the rapid response of the fire department not only saved the structure but also managed to spare most of the Wolfe family's furnishings. At present, the house is awaiting costly restoration.

Things to See and Do

Prior to the fire, staff members led guided tours of most of the rooms in Julia Wolfe's Old Kentucky Home. Particular emphasis was given to connecting events in Thomas Wolfe's life in the house with incidents detailed in his books. Tours are still given but are currently limited to walks outside the home. A modest fee is charged for the tour, which lasts about half an hour.

The visitor center has a slide show that gives an overview of the author's life, while the exhibit area showcases a number of family heirlooms and some of Thomas Wolfe's personal effects. Many of Wolfe's published writings are available for purchase at the center.

Address and Location

Thomas Wolfe Memorial
52 North Market Street
Asheville, N.C. 28802
828-253-8304/828-252-8171 (fax)
www.ah.dcr.state.nc.us/sections/hs/wolfe/wolfe.htm

The Thomas Wolfe Memorial is located within blocks of downtown Asheville and is easily reached from Interstate 240 Bypass.

Opposite page, top left: The dining room was a lively place for Mrs. Wolfe's boarders to chat over their morning and evening meals. Bottom left: The kitchen was the site of hectic activity when meals were being prepared. Right: Thomas Wolfe and his mother posed for this photo on the porch of her Asheville boardinghouse (photo courtesy of North Carolina Department of Cultural Resources). This page, top left: The parlor was a popular place for boarders to gather in the evenings for music and discussion. Bottom left: This view from the second-floor landing looks into the room occupied by Eugene Gant in Look Homeward, Angel. *Above: This simply furnished room was one of the boarders' bedrooms.*

Ashe, Samuel A'Court. *History of North Carolina.* Vol. 1. Greensboro, N.C.: Charles L. Van Noppen, 1908.

Barefoot, Daniel W. *Touring North Carolina's Revolutionary War Sites.* Winston-Salem, N.C.: John F. Blair, Publisher, 1998.

Barrett, John Gilchrist. *North Carolina As a Civil War Battleground: 1861-1865.* Raleigh: North Carolina Department of Cultural Resources, 1991.

Brooks, Jerome E. *Green Leaf and Gold: Tobacco in North Carolina.* Raleigh: North Carolina Department of Cultural Resources, 1975.

Camp, Cordelia. *Governor Vance: A Life for Young People.* Raleigh: North Carolina Department of Cultural Resources, 1980.

Corbett, John Richard. *Ships by the Name of North Carolina.* Wilmington, N.C.: Corbett Publications, 1961.

Corbitt, David Leroy. *The Formation of the North Carolina Counties, 1663-1943.* Raleigh: North Carolina Department of Cultural Resources, 1996.

Crabtree, Beth G. *North Carolina Governors, 1585-1958: Brief Sketches.* Raleigh: North Carolina Department of Archives and History, 1958.

Ellis, Marshall. "A Place Called Somerset." *Our State* 67 (August 1999): 96-102.

Fonvielle, Chris E., Jr. *The Wilmington Campaign: Last Rays of Departing Hope.* Campbell, Calif.: Savas Publishing Company, 1997.

Fowler, Robert H. "Mouth of the South." *Civil War Times Illustrated* 37 (June 1998): 46-52, 76.

Funk, Linda. *The Reed Gold Mine.* Raleigh: North Carolina Department of Cultural Resources, 1989.

Galloway, Duane, and Jim Wrinn. *Southern Railway's Spencer Shops, 1896-1996.* Lynchburg, Va.: TLC Publishing, 1996.

Gragg, Rod. *Confederate Goliath.* New York: HarperCollins, 1992.

Haas, Irvan. *Historic Homes of the American Presidents.* Mineola, N.Y.: Dover Publications, 1991.

Hill, Michael. *Guide to North Carolina Historical Markers.* Raleigh: North Carolina Department of Cultural Resources, 1990.

Jordan, Weymouth T. *The Battle of Bentonville.* Wilmington, N.C.: Broadfoot Publishing Company, 1990.

Kleinkneckt, C. Fred. *Anchor of Liberty.* Washington, D.C.: Supreme Council of the 33rd Degree of the Ancient and Accepted Scottish Rite of Freemasonry of the Southern Jurisdiction of the United States of America, 1987.

Knapp, Richard F. *Golden Promise in the Piedmont: The Story of John Reed's Mine.* Rev. ed. Raleigh: North Carolina Department of Cultural Resources, 1999.

Lee, Robert E. *Blackbeard the Pirate: A Reappraisal of His Life and Times.* Winston-Salem, N.C.: John F. Blair, Publisher, 1974.

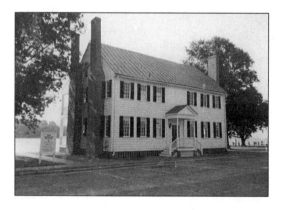

Little, M. Ruth. *Coastal Plain and Fancy: The Historic Architecture of Lenoir County and Kinston, North Carolina*. Kinston, N.C.: City of Kinston and the Lenoir County Historical Association, 1998.

Mitchell, Ted. *Thomas Wolfe: A Writer's Life*. Rev. ed. Raleigh: North Carolina Department of Cultural Resources, 1999.

Moore, Elizabeth Vann. *Guide Book: Historic Edenton and Chowan County*. Edenton, N.C.: Edenton's Woman's Club, 1989.

Powell, William S. *The War of the Regulation and the Battle of Alamance, May 16, 1771*. Raleigh: North Carolina Department of Cultural Resources, 1976.

Purdue, Theda. *Native Carolinians: The Indians of North Carolina*. Raleigh: North Carolina Department of Cultural Resources, 1995.

Ravi, Jennifer. *Notable North Carolina Women*. Winston-Salem, N.C.: Bandit Books, 1992.

Reeves, Linda. *Bath Town*. Raleigh: North Carolina Department of Cultural Resources, 1977.

———. *Historic Halifax*. Raleigh: North Carolina Department of Cultural Resources, 1976.

———. *Town Creek Indian Mound*. Raleigh: North Carolina Department of Cultural Resources, 1976.

Robinson, Charles M., III. *Hurricane of Fire: The Union Assault on Fort Fisher*. Annapolis, Md.: Naval Institute Press, 1998.

Rowland, William H. *Neuse Commemorative Medal*. Pamphlet published by the Lenoir County Committee
of the North Carolina Confederate Centennial Commission.

South, Stanley A. *Indians of North Carolina*. Raleigh: North Carolina Department of Archives and History, 1965.

Trotter, William R. *Ironclads and Columbiads: The Civil War in North Carolina—The Coast*. Winston-Salem, N.C.: John F. Blair, Publisher, 1989.

Vatavuk, William M. *Dawn of Peace: The Bennett Place State Historic Site*. Durham, N.C.: Bennett Place Support Fund, 1989.

Wadeling, Charles W., and Richard F. Knapp. *Charlotte Hawkins Brown and Palmer Memorial Institute*. Chapel Hill: University of North Carolina Press, 1999.

West, John Foster. *Lift Up Your Head, Tom Dooley*. Asheboro, N.C.: Down Home Press, 1993.

World Book of America's Presidents. Chicago, Ill.: World Book Encyclopedia, 1990.

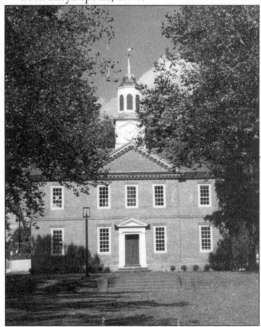

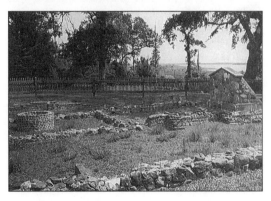

Index